KAREN ROSENKRANZ

City Quitters

Creative Pioneers Pursuing Post-Urban Life

FRAM3

Contents

CITY QUITTERS
Creative Pioneers Pursuing Post-Urban Life

When a friend of mine, a photographer heavily inspired by London's grittier side, decided to relocate from Hackney to rural Sweden in 2013, the thought of 'quitting the city' first popped into my head. Would it be possible for him to say goodbye to city life for good? Would he be able to lead a creative post-urban existence? The idea seemed crazy.

As a trend forecaster my job is to spot new patterns in people's attitudes before they develop into mainstream concepts. For me there is no better place to be than a bustling urban metropolis. The colourful mix of cultures creates a certain energy. Ideas spread quickly. Nowhere else, it appears, is the zeitgeist more palpable than in a commercial capital like London.

But lately I've noticed an increasingly predictable global formula of brands, behaviours and biases, all being broadcast through carefully curated social media feeds. What's new in London, Los Angeles, Berlin or Shanghai is becoming more and more similar. What if fresh, original thinking is no longer the preserve of a thriving megacity?

As they become denser, the pressures on cities and their inhabitants are growing. Competition is fierce and the cost of living is high. For creatives and entrepreneurs, 'making it' in the city is getting harder and harder. Add to this constant connectivity and long working hours and one wonders if the city really is the best environment to establish a sustainable creative practice.

The desire for a simpler life — away from the crowds and closer to nature — is nothing new. Economic instability and rising anxiety levels caused by our self-inflicted technology addiction have all but intensified our yearning to balance the stresses of modern life. City dwellers are picking up crafty, bucolic hobbies in ever-greater numbers, from woodcarving to pottery and pickling. Holidays to off-grid, remote locations are booming and weekend editorials now feature designer axes and recipes for foraged herbs. We have developed a definite fetish for all things rural.

But what does it actually mean to leave city life behind and settle in the country? What lies beyond this romanticised notion and highly stylised ideal? Does the reality of living in the countryside fulfill our craving for a better, simpler and more creative life?

This book is an attempt to shed light on what rural life can be like today, with all its joys and challenges, offering a fresh look at how people and scenes

can thrive outside urban spaces. The global trend of urbanisation is irreversible, but there are alternative approaches for creative living and working.

From the individual's point of view, this means developing a survival strategy that makes life in the countryside exciting and inspiring: it is an opportunity to create culture rather than consume it. And for rural areas and small towns, creative thinking can provide a boost to the social fabric, reviving the populations of places that have been abandoned by young people, and reversing economic decline.

More flexible work arrangements and modern communication make this shift possible. It allows people to stay connected and feel part of the conversation no matter where they are based. The Internet has brought about new economic models, enabling small businesses to sell to customers directly, and grow their own audience from anywhere in the world. For many creative professionals it is no longer necessary to choose between a career and an environment that supports their ideal lifestyle − having both is entirely possible.

Maybe, over time, rural areas can become important counterparts to urban centres, as they offer more time and space to experiment, allowing people to find their own voice, unhindered by constant distraction and comparison. There is huge potential for transformation in the countryside, and as the worlds of art and architecture start to shift their attention here, I hope to see a new visual language emerging − a fresh aesthetic outside of the folkloristic and sanitised expressions of country life; a sphere where the traditional and the innovative can coexist to shape an exciting future.

CITY QUITTERS is not a book about interiors or design trends. It is a book about people and their perspectives. It portrays creative pioneers pursuing post-urban life, each demonstrating a slightly different way of making it work: from experimental co-habitation in a renaissance castle, to creating oversized artworks on a farm, to establishing a demo ground for sustainable living. Some are fluid and nomadic, while others seek solitude, but all offer a new vision for ruralism beyond rustic pastimes and nostalgia.

KAREN ROSENKRANZ

NADIA RIVELLES founder of Rivelles

'My creativity was inspired by city life. Now nature is my source of inspiration'

Linz → Barcelona → Ibiza → Berlin → Beirut → Vienna → **Götzwiesen, Lower Austria, Austria** population 80

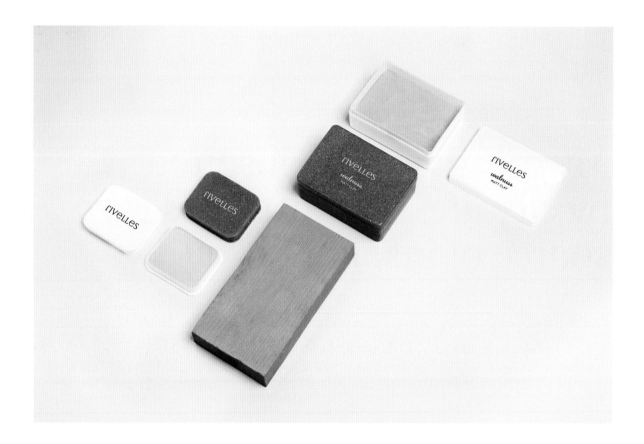

Ten years, 25 houses, and six cities. A nomadic track record that suggests a life destined to be eternally cosmopolitan. But a chance encounter with a bungalow deep in the Austrian woods sparked a change that would alter the lives of NADIA *and her partner Mario entirely — marking the beginning of a new family business, new routines, and a new sense of home.*

What brought you to this part of the world? We were living in Lebanon. My husband Mario had quite a lot of work as a photographer, and I helped with the post-production. We would have loved to stay, but getting a permanent visa was tricky. We came back to Austria and lived in Vienna for a while, but it didn't really suit us. So we started to look for a home in the countryside that was still close to the city.

How did you find this particular place? It found us. We discovered an amazing 70s bungalow in Götzwiesen and instantly fell in love. We didn't know the village or the area, but decided it was where we wanted to live. Now my sister lives in the bungalow and we're building a house for ourselves on a new plot.

Where did the inspiration come from for Rivelles? It all started when we cut down a row of trees behind the old house. Suddenly all these different plants started to grow in their place and, after a bit of research, we found that many had medicinal properties. We experimented and started mixing our first shampoos and lotions at the same time as I was reading about the ingredients in conventional cosmetic

PREVIOUS SPREAD LEFT The Vienna Woods, one of the largest forests in Europe, provides both inspiration and ingredients for Rivelles' range of organic products.

TOP Rivelles is committed to sustainability — from sourcing local, natural ingredients to using eco-friendly packaging made from bioplastic.

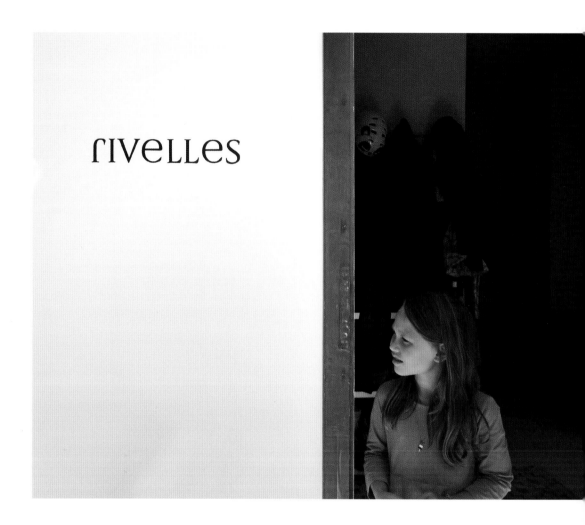

ſivelles

NADIA RIVELLES 'After all these years of moving around I became very bored and oversaturated with popular culture. Everything starts to look the same'

products. Having Yva [Nadia and Mario's child] made me more aware of the stuff we expose our kids to, and I was really shocked. Developing organic, natural cosmetics seemed something worth pursuing. Up to that point Mario's work and mine revolved around developing concepts or advertising for other people, but to create your own product and brand is a lot more satisfying.

How do you manage the demands of a successful business in such a remote place? My sister is a doctor in a medical laboratory, so she got involved with product development. My mum looks after sales and distribution and runs our shop in Linz. We're a real family business [laughs]. Mario does the photography. He is also a trained hairdresser, so he developed all the shampoos and hair styling products. Everything worked out quite nicely, and we're proud to say we can make a living from doing what we love. At the moment we forage a lot of wild plants, but it's quite labour intensive. The next step is to grow our own ingredients.

Are all your products produced in Götzwiesen? Yes, everything is made in our laboratory on site. We would like to source all our packaging locally as well but we can't get it here, so we ship it from Germany. It's made from a brown synthetic bioplastic that is 40% wood. It's a really exciting product.

How have your lives changed since moving to the countryside? The best thing here is the peace and quiet. Every day I go for a walk in the woods. I used to go shopping or meet friends for coffee, now I go for walks [laughs]. If I'm stressed or struggling with something, I just go for a walk in the woods and everything is fine. Then I go back to the studio and I feel happy. I love being able to enjoy all four seasons. I hated winter in the city, but now

PREVIOUS SPREAD Nadia's studio offers beautiful views across the surrounding landscape. The studio has been built with sustainability in mind, too — the structure, made from a timber frame, was bought second hand.

TOP Becoming a mother made Nadia look more closely at the ingredients of the skincare products she was using. After realising how harmful some of the chemicals can be, she decided to create her own alternatives — and the idea for Rivelles was born.

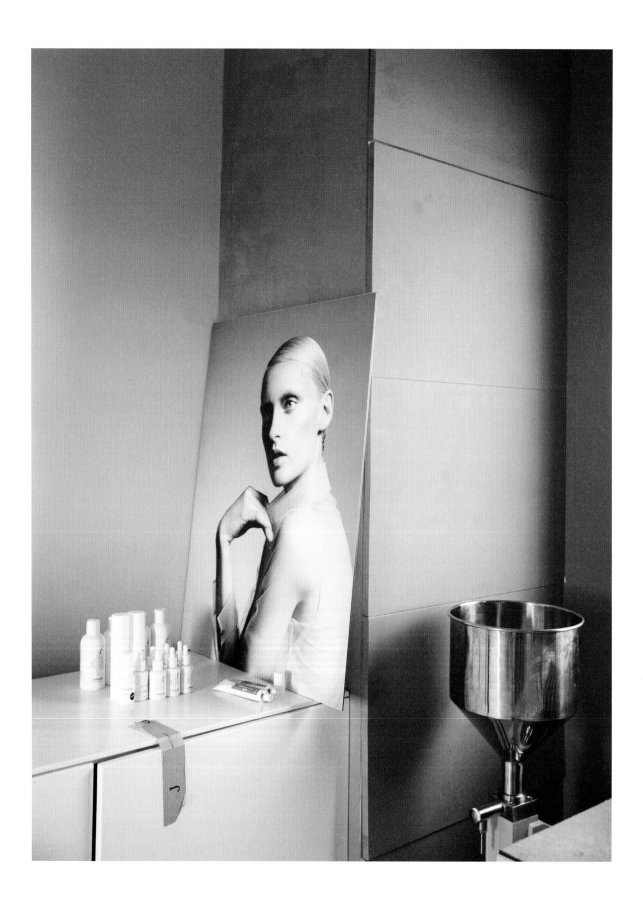

we get our snowboards out and ride down our little hill. Rain, fog or thunderstorms are great here, too. It's amazing how the atmosphere can change so quickly. You see some incredible spectacles in nature.

Did you have any connection to this part of Austria before? Not at all. In the beginning it was a bit of a shock. It took some readjusting. I'm a total city person, and my creativity was inspired by city life. Or, at least that's what I thought. Now nature is my source of inspiration.

How aware are you of what's going on in the city? I'm still very aware of trends even though I live in the middle of nowhere. After all these years of moving around I became very bored and oversaturated with popular culture. Everything starts to look the same everywhere and I just didn't appreciate it anymore. Now, I can keep up to date with the things I'm interested in online, and don't feel as bogged down by it all.

Your products are made in a very ethical and sustainable way. What does living sustainably mean for you on a personal level? Most of our food comes from the local farmers, which means there's little or no packaging.

We are mindful about not buying too much stuff, and buy a lot of things second hand. Almost everything we have has been used before, from our furniture to the house. Our new studio is made from a timber frame that used to stand somewhere else. We bought it online and stored it until we had a piece of land to rebuild it on.

Has living here had an impact on your health? Generally I would say we both feel better, but there was a time when I had to stop working for a while. It was when we first started the business and Yva was still a little child. We were working other jobs to make ends meet, and it just got too much. I couldn't function anymore.

Mario dragged me out of the house every day to go for walks, and that was the only thing I did during that time. Back then we decided to get a dog to make sure we stuck to the routine of taking daily walks. Otherwise it's easy to get lazy. I recovered quite rapidly after that.

Do you approach work differently now? I have to. It's hard for me, because I love what I do. But during those 6 months I really lost the desire to work. I didn't want to do anything at all. It felt as if someone had taken away my greatest passion. Now I know exactly when things are becoming too much, and I make sure I slow down. Then we sit in the garden and just chill out.

Or we go to Vienna and have a nice meal. Things have really fallen into place for us since we've moved here, much more so than in the city. We are less distracted. And when we have a bit of downtime, we're more inspired to come up with ideas for future projects. We're much more focused.

What are your plans for the future? We are not big planners. We're very spontaneous, nomadic people. But this is the place where we've managed to stay the longest out of everywhere we've lived. Between 2000 and 2010 we lived in 25 different houses. We were always searching for something else, always restless.

For the first time I feel settled, and understand that we were missing something before. This is a place where we can stay — our own space to roam and just 'be'. I feel completely free here.

→ RIVELLES.COM

LEFT All of Rivelles' products are produced in their laboratory on site.

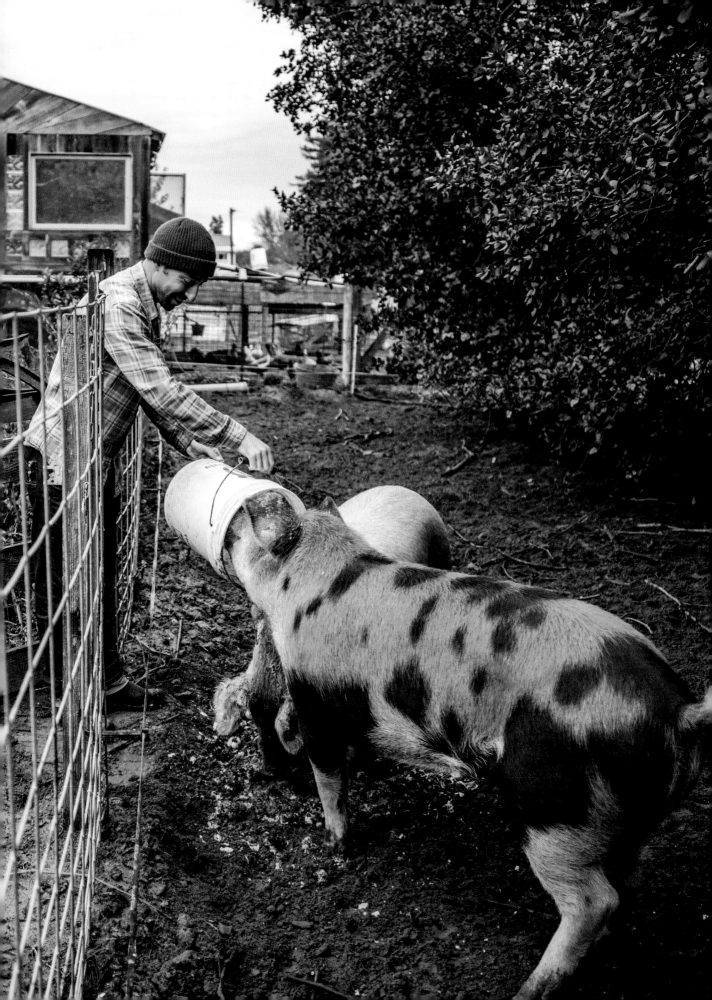

BRIAN GABERMAN photographer

'It's getting harder and harder to understand how I ever lived in a city. The more you're removed from it, the more it seems an unnatural habitat for humans'

Louisville → San Francisco → **Sebastopol, California, United States** population 7,700

French doors on our office, so I look directly out onto the garden. I thought that would be a good thing, but it's kind of torture – I just want to go out there. I had to put up blackout curtains that I close when I need to work, at least half way, so I can't really see the garden. It helps.

How did you acquire all your gardening and DIY skills? Our house is over 100 years old, and there's just no way I can afford to pay people to do all the things that need fixing. Every time I hired someone, I used it as a private lesson. I would ask a lot of questions and observe very closely. I learned to fix a burst pipe, or wire up our new workshop. I love it. It's been very empowering to figure out that with a little bit of effort and research you can do just about anything.

Do you grow all of your own food? We don't go to the store for any vegetables at all. We just eat what we grow or trade.

There's always an excess of certain things. Come spring we'll have tons of asparagus – more than we can ever eat. My wife has traded all kinds of things for asparagus: chocolate, liqueurs, jam, and chicken.

How did you settle into the local community? I don't remember trying, it just happened. Having kids helps a lot – they go to a Waldorf school, which is very community-based, so we made a lot of friends through that.

Sebastopol is a very welcoming place. I think it's one of the reasons it's getting so popular. I make the joke that first I always used to get stuck behind a tractor, now I get stuck behind a Tesla [laughs].

It's a very quirky community – you've got the older generations of farmers and the newer hipster generation. It's a weird mix, but everybody coexists happily. Overall the community is pretty great, if anything it errs on the side of being too hippie [laughs], but I'll take that over too normal or conservative.

Has your approach to photography changed at all, now you live in a rural environment? It absolutely has an effect on you. I might have focused on the people before, whereas now I focus more on shapes and light.

The brand I work for, Element Skateboards, are based in Southern California, and everybody who works with them lives down there, apart from me. I told them from day one I'm never going to move down there. Creatively there is nothing that excites me; I just couldn't survive there. Luckily they are cool with that.

Where I am here is very important to me – not just for my sanity, but also for my perspective.

For a long time I would get grumpy when I went on trips. I'd be like, 'this is not how people should live anymore, this just feels wrong'. But now when I'm in a city, I just enjoy what it has to offer: I eat at good restaurants, go out, and see things I don't get to see here. Then when I get home I put my hands in the dirt and it feels really good and grounding. I have found a balance.

Travelling really wears on you, and sometimes I feel I need a break, but as soon as I'm home for 3 or 4 weeks, I'm ready to go somewhere again. I need another adventure. I've been on this cycle for more than 20 years now, it's engrained in me – I need both.

How do you keep up to date with what's happening in the world of skateboarding? I use Instagram to keep connected to the guys I work with, and to see what's happening in the industry. All of my best friends live in Southern California, so it's also my only way to stay in touch with them. I hardly ever post though. I'm an introvert and just hang with my family and friends that are nearby.

I don't use any other social media platforms – Instagram alone is more than I can keep up with. I just don't like looking at a screen all day.

Does being a bit removed from the scene help you keep your own perspective or aesthetic? If I do too much research or know too much about something, it hurts me when I'm trying to work. It gets in my head and takes over.

RIGHT Brian and his wife brought up their children without a TV. While they accept technology is a growing part of their young lives, they hope they'll continue to spend as much time outside as possible.

BRIAN GABERMAN photographer

'It's getting harder and harder to understand how I ever lived in a city. The more you're removed from it, the more it seems an unnatural habitat for humans'

Louisville → San Francisco → **Sebastopol, California, United States** population 7,700

BRIAN *is one of skateboarding's most esteemed photographers. But after the birth of his first child, his attitude towards the urban space that his work revolved around began to change. A radical move to a healthier environment and a cabin in the woods followed, but proved too isolating for his wife and young son. Now, settled in the small town of Sebastopol north of San Francisco Brian has seemingly found the perfect balance between his urban-focused career and a rural, self-sufficient existence working the land to provide food for the family.*

What made you want to leave the city? We were living in San Francisco when we had our first child. We used to walk to the coffee shop every morning with him in the stroller. When our son was about 6 months old, we both realised we were tired of stepping over heroin needles on the sidewalk. We looked at each other and said: 'We've got to get out of here!'

We liked being in the city. I was working as a skate photographer and was out on the streets every day. The idea of leaving San Francisco was kind of crazy, but we were just fed up. At that time we were offered the option of taking over the family cabin out in the middle of the Redwood Forest, about an hour and a half from San Francisco. We just went for it.

It couldn't have been more of a shock going from the Mission [district] in San Francisco to a 200 m^2 cabin on the edge of a creek, surrounded by 90-m-high redwood trees, with a 6-month-old baby. It was pretty wild, but we were young and bold.

How did you cope with such a drastic change? I went to the city almost every day to maintain that hustle of getting out on the street with skateboarders. It was pretty exhausting, the commute alone, but also the contrast. As beautiful and serene as it was, it was really isolating for my wife. I travel a lot and I'd be gone for 2 weeks, and she'd be there with the baby on her own.

After 2 years we moved to Santa Rosa where my wife Noelle grew up. We were there for a few years before we realised it was still too much city for us. So that's when we moved to Sebastopol, which is basically right in between where the cabin was and Santa Rosa. It's the perfect balance of the two.

How did you find this place? I was sharing a studio space with a photographer friend of mine in Sebastopol, and we were spending more time there than in Santa Rosa — it was the place where we wanted to be. It had a small-town feel, but still had good restaurants and cool people.

I jokingly said to my friend that we should find some property in Sebastopol together. We never made a conscious decision, but we started looking at properties that had two houses on them, almost as a joke. Then suddenly it became real. We found one we liked, bought it, and have both been living here since 2008.

What have you been up to since you moved? I'm a huge gardener, and we raise pigs, chickens and ducks. We grow fruit trees and berry hedges, and my wife raised alpacas for fibre for a while.

I've continued to travel the world as a skateboard and lifestyle photographer, and released a book of skateboard photographs in 2013.

I'm also a very average but enthusiastic guitar player. It's one of my favourite things. I'm clearly not meant to be a great musician, but I absolutely love it, it's my grounding mechanism. It's the first thing I do in the morning. I drink my coffee and play guitar while the kids eat their breakfast. It's funny, because I'm not that great, but when I travel my kids say they miss the guitar in the morning.

How do you spend your time here? If I have to do post production I work in my office, but more likely than not I will go out and work in the garden. I'll do things like take care of the chickens, feed the pigs, put up a new fence, or plant things. There's always more to do on the list than I will ever have time for.

If I don't jump into the office work right away, I'll usually put it off. Foolishly I put

PREVIOUS SPREAD Brian describes himself as a 'huge gardener', and also raises pigs, chickens and ducks on his farm in Sebastopol.

LEFT The Gaberman family grow all their own vegetables, and instead of shopping at the supermarket, trade home-made produce for the things they need.

French doors on our office, so I look directly out onto the garden. I thought that would be a good thing, but it's kind of torture – I just want to go out there. I had to put up blackout curtains that I close when I need to work, at least half way, so I can't really see the garden. It helps.

How did you acquire all your gardening and DIY skills? Our house is over 100 years old, and there's just no way I can afford to pay people to do all the things that need fixing. Every time I hired someone, I used it as a private lesson. I would ask a lot of questions and observe very closely. I learned to fix a burst pipe, or wire up our new workshop. I love it. It's been very empowering to figure out that with a little bit of effort and research you can do just about anything.

Do you grow all of your own food? We don't go to the store for any vegetables at all. We just eat what we grow or trade.

There's always an excess of certain things. Come spring we'll have tons of asparagus – more than we can ever eat. My wife has traded all kinds of things for asparagus: chocolate, liqueurs, jam, and chicken.

How did you settle into the local community? I don't remember trying, it just happened. Having kids helps a lot – they go to a Waldorf school, which is very community-based, so we made a lot of friends through that.

Sebastopol is a very welcoming place. I think it's one of the reasons it's getting so popular. I make the joke that first I always used to get stuck behind a tractor, now I get stuck behind a Tesla [laughs].

It's a very quirky community – you've got the older generations of farmers and the newer hipster generation. It's a weird mix, but everybody coexists happily. Overall the community is pretty great, if anything it errs on the side of being too hippie [laughs], but I'll take that over too normal or conservative.

Has your approach to photography changed at all, now you live in a rural environment? It absolutely has an effect on you. I might have focused on the people before, whereas now I focus more on shapes and light.

The brand I work for, Element Skateboards, are based in Southern California, and everybody who works with them lives down there, apart from me. I told them from day one I'm never going to move down there. Creatively there is nothing that excites me; I just couldn't survive there. Luckily they are cool with that.

Where I am here is very important to me – not just for my sanity, but also for my perspective.

For a long time I would get grumpy when I went on trips. I'd be like, 'this is not how people should live anymore, this just feels wrong'. But now when I'm in a city, I just enjoy what it has to offer: I eat at good restaurants, go out, and see things I don't get to see here. Then when I get home I put my hands in the dirt and it feels really good and grounding. I have found a balance.

Travelling really wears on you, and sometimes I feel I need a break, but as soon as I'm home for 3 or 4 weeks, I'm ready to go somewhere again. I need another adventure. I've been on this cycle for more than 20 years now, it's engrained in me – I need both.

How do you keep up to date with what's happening in the world of skateboarding? I use Instagram to keep connected to the guys I work with, and to see what's happening in the industry. All of my best friends live in Southern California, so it's also my only way to stay in touch with them. I hardly ever post though. I'm an introvert and just hang with my family and friends that are nearby.

I don't use any other social media platforms – Instagram alone is more than I can keep up with. I just don't like looking at a screen all day.

Does being a bit removed from the scene help you keep your own perspective or aesthetic? If I do too much research or know too much about something, it hurts me when I'm trying to work. It gets in my head and takes over.

RIGHT Brian and his wife brought up their children without a TV. While they accept technology is a growing part of their young lives, they hope they'll continue to spend as much time outside as possible.

BRIAN GABERMAN 'You raise your kids off screens for most of their lives, but you put a phone in front of them and they'll stare at that thing for hours if you let them'

You won't even realise it, but you're trying to emulate something you've seen. It just seeps in. I've always been susceptible to that so maybe that's why I ended up, unintentionally, being this far removed from it all.

It looks like your kids spend a lot of time outdoors. How much time do you let them spend on social media or online? It's a constant battle in our house. It's funny because our kids were raised without TV; they get dirty, and they are outside all the time. You raise them off screens for most of their lives, but you put a phone in front of them and they'll stare at that thing for hours if you let them. That's how they communicate with their friends now, they hang out on their phones together.

It's kind of disheartening, but it's just the way the world is right now. We put in all of this hard work and they end up in the same place [laughs]. Well, that's not completely true – they know how to amuse themselves, how to be creative, how to sit down and draw if they're bored.

Do you also go out and explore the countryside? Yes, the landscape is absolutely beautiful. We have the Redwood Forest and the ocean. It's very rough and rugged. I love it. Often, when I come back from a trip, the first thing we do is drive out to the ocean. It feels like a release, and everybody reconnects.

It's getting harder and harder to understand how I ever lived in a city. The more you're removed from it, the more it seems an unnatural habitat for humans.

Can you explain? It becomes glaringly obvious how unhappy a lot of people look in the city. I just see a lot of people staring at their feet or their phone, wrapped up in their own world, whereas here most people are smiling and want to look you in the eye.

Yeah, it's great to have all these restaurants, music venues and shops around, but I think there's a huge cost. A lot of people I know love living in the city, and it feeds them, but it doesn't feed me.

I think people are starting to sense that there is a hollowness to living in the city. Something is missing from their lives and they don't know what it is. Why do they always feel unsatisfied? Maybe it's the loss of connection to a place, to land, to nature.

Life in the city has become so convenient – you have everything at your fingertips, but somehow that's less satisfying. If you have to work hard for something you appreciate it more. You really do. There are times when I look at my plate and everything on it came from our property. It's amazing. When you live in a city you lose appreciation for all these little things, which are what life ends up really being about in the end. The little victories.

A city is a very fragile environment. When there's a hurricane and suddenly all the grocery shops are empty and there's no water, you realise we live a very fragile existence.

Here we're covered for about 6 months. It's a nice feeling of security.

I mean, it's hard work, with all the ups and downs imaginable, but I always go to bed exhausted in a good way. I wouldn't change it for anything.

What are your plans for the future? I plan on trying to produce more food myself. And in a perfect world, I'd like to apply my photography towards promoting this kind of living to others.

→ GABERMAN.COM

PREVIOUS SPREAD After the harvest, Brian turns his excess tomatoes into sauce, then bags and freezes it. For the past 9 years, he says, they haven't had to buy a single jar.

RIGHT Brian's wife Noelle raised alpacas for fibre. In the future, the couple's wish is to become even more self-sufficient – growing more of their own food, and promoting this way of life to more people.

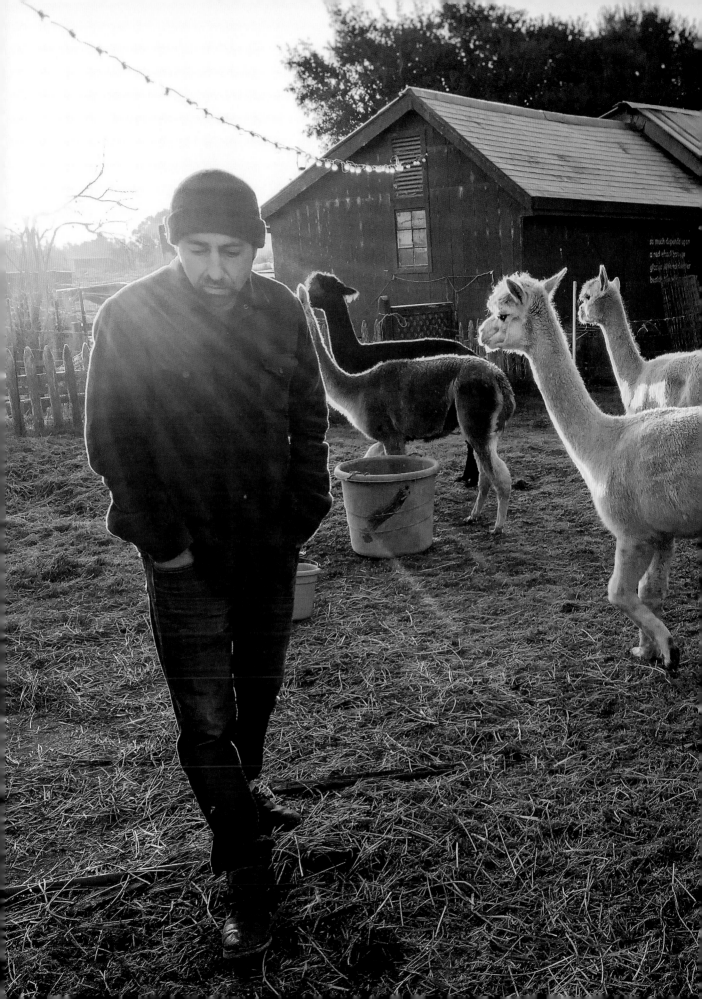

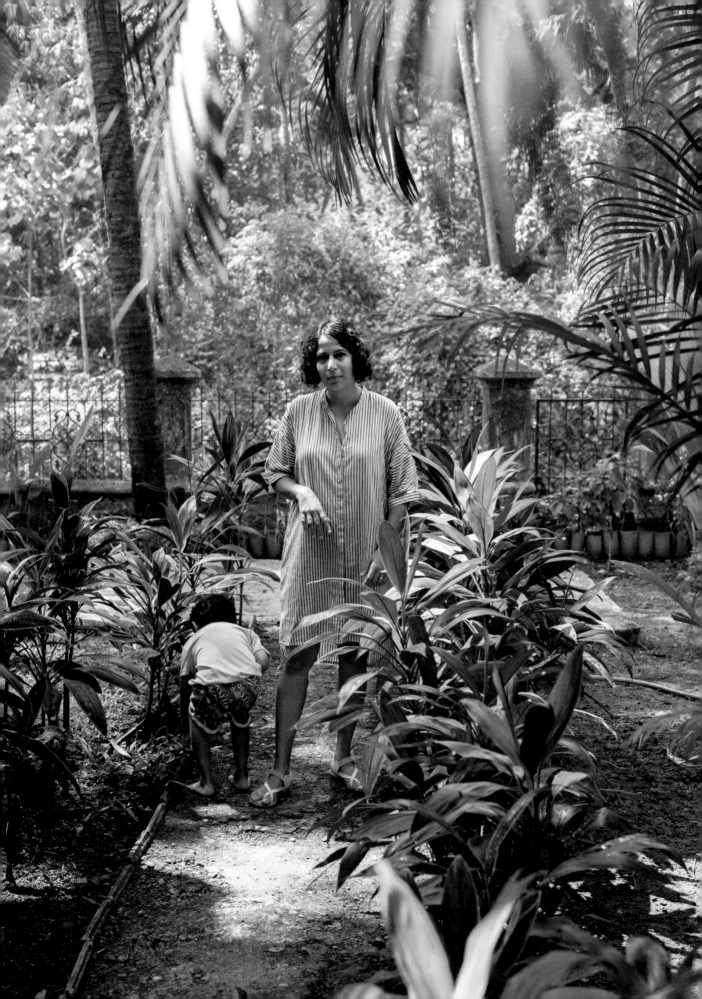

AMITA KULKARNI architect, co-founder of SAV

'I still believe that cities are a necessity in our world, but I do think we need to start thinking about them in a very different way'

Mumbai → London → **Parra, Goa, India** population 4,400

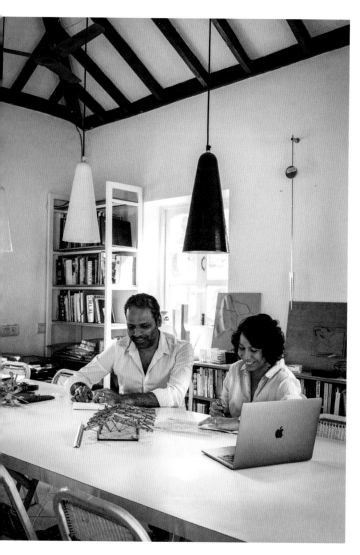

thought, 'why not use this opportunity to move there until the project is finished?' We were interested to see what it would be like to live somewhere rural and have a different kind of lifestyle. In London you need to be constantly on your toes. You need to make money to survive, and having a small child made it quite hard to keep up with the pace. We thought moving to a place like Goa would give us more time to reflect and improve our method of working.

How have you settled in? It took some time to get used to living here. It was a massive decision not to go back to Mumbai – where we're both originally from – and move to a rural place like Goa instead. In the beginning we really struggled with the fact that there are so few people around. We used to live in Shoreditch in east London and would always hear people until late at night. Here you don't hear anything after 7 o'clock, which was quite spooky for us initially. Also the Indian countryside is not that developed. Sometimes there is no water or electricity, or no gas for cooking.

Another issue was getting our team, who were based at our Mumbai office, to move to Goa with us. In India people don't move to the countryside. We tried to explain how experiencing life outside the city would give them a fresher perspective, and that being a good architect doesn't necessarily mean seeing buildings all the time or working nine to five. Three people moved with us, which was amazing, but we also had to find new people to work with us – and make sure they understood why we chose Goa.

How did your team react? Like us, they went through ups and downs. They are much younger than us, and often young graduates just want to party all the time. But I think after the first 3 months they started to realise that going for a walk in the fields on a foggy morning does something to you as a creative individual.

Split between London and India, **AMITA** *and her partner Vikrant's architecture practice offers the pair a wealth of opportunity to travel. So when one of their most recent projects, in the Indian tropical paradise of Goa, offered the opportunity for more, it was a chance too good to refuse. They packed up their home in east London and headed for a simpler way of life that would reveal new ideas, improve their practice, and bring about a fresh perspective on design for the future.*

What first attracted you to Goa? We had been working on a project here for a year while we were still based in London when we

TOP The architecture practice is an open-plan space with white walls and a wooden pitched roof – a warm, inviting space for the team with lots of natural light.

RIGHT The studio is located in an independent Indo-Portuguese style structure within a coconut grove.

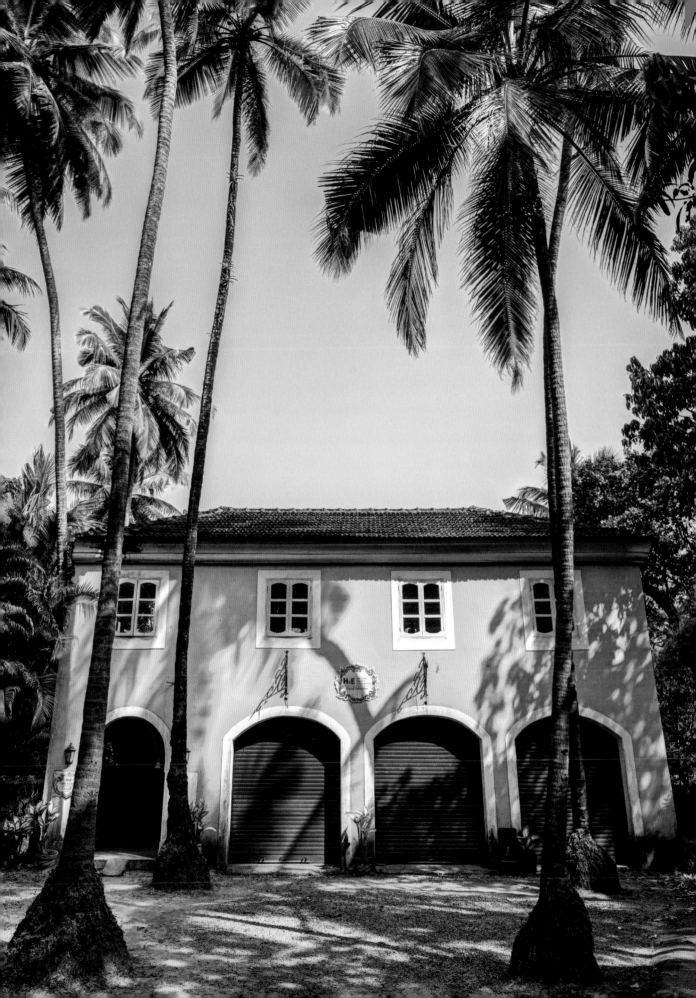

AMITA KULKARNI 'Going for a walk in the fields on a foggy morning does something to you as a creative individual'

It brings out things that would never happen in Mumbai because you are always distracted. I think when they realised this, they loved it.

Has it changed your way of working? We used to be inspired by nature in terms of efficiency and design. Now we're thinking in terms of natural systems and eco-environments where everything balances each other out. Balance is something that is really needed in larger cities today.

Because we're outside of the urban environment we constantly think about what we can take to cities that will bring the calm, peace, and satisfaction we have here. Architecture should be able to change and adapt, just like nature. Can we introduce systems that grow and adapt? It doesn't have to be a quick transformation; it could be 2 months, 2 years, or 20 years.

So has living here made you think about cities in a new way? I still believe that cities are a necessity in our world, but I do think we need to start thinking about them in a very different way. They are hectic, congested and polluted places, but there are ways to counter these problems. The first step would be to allow for greater flexibility. For example, giving people the flexibility to work from home so they don't have to be on the underground every day.

Having more time for reflection seems to be a key issue for you. Our cities have become economic powerhouses, but they're robbing people of time. When you go to the countryside you really start to understand that. Both our planet and people would benefit if we can shift the emphasis from money to time.

Staying late is very normal in architecture offices. But now we are forcing ourselves to be efficient and leave the office on time, which has been quite a turnaround for us.

How does Goa compare to London? India is quite chaotic, but Goa is a unique pocket that has been a Portuguese colony for a long time. Goans love the idea of 'sossegado', which is a Portuguese concept to take life slowly. Being Londoners we came with this mindset of wanting things immediately. In Goa – no way. You have to give things time. A plumber is going to

come when he comes. You just have to accept it. There is no point being enraged.

Our environment couldn't be more different. Goa is close to the beach, and has beautiful coconut palms everywhere. It also has amazing produce, with lots of vegetables and fruits grown locally.

Our office is an amazing space. It's a very small set-up, in an old open-plan Portuguese house. We go to work after we drop our son at nursery, but time can be flexible – a lot of the time we work from home as well. Sometimes we have a very long lunch break, or we go to the beach for lunch.

Do you think the move has affected your health at all? Yes, I'm a much healthier person now than I used to be in London. I had a young child and was trying to run a business and teach. By the time I left I was so tired; now I feel totally regenerated as a person, mentally and physically.

Vikrant and I decided that if we do come back to London we want to dedicate a month every year to set ourselves up in a different part of the world and work from there. That will give us a fresh perspective again.

Architecture projects usually take ages to finish, and it's easy to lose the passion you initially had. You just want to finish it. But I think having this kind of distance, or being in a different environment, would enable us to get back into a project and be excited about it again.

Has your consumption changed at all? I was never that consumption driven. We had a very minimal lifestyle in that sense. The only things we had to move from London were books and Vikrant's music equipment [Vikrant is a music producer and DJ in his spare time].

I don't see the point in consuming too much. That doesn't mean that you shouldn't get good things, but you should see real value in

PREVIOUS SPREAD Amita and her family live in a small village surrounded by rice fields, centred around a beautiful 15th century Portuguese church.

RIGHT The studio embraces both new technologies and traditional crafts – and often incorporates both when creating physical models to explore a variety of materials and fabrication methods.

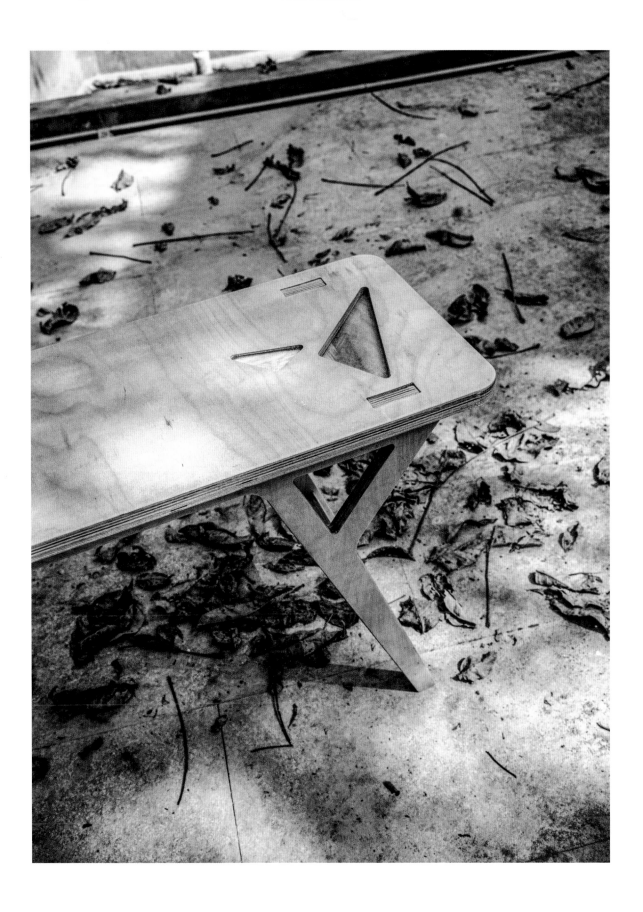

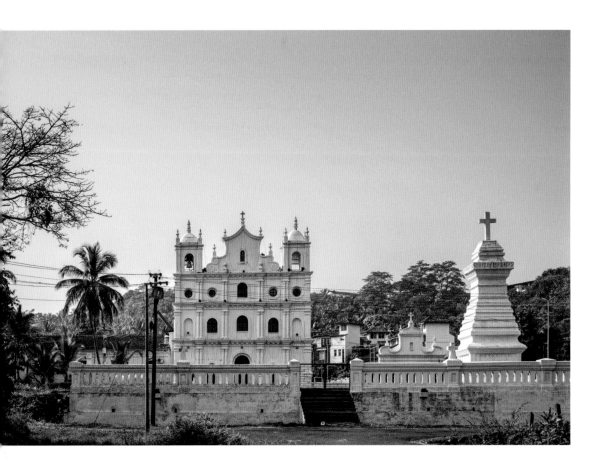

them and how they make a difference to your everyday life. Things don't give you time. I want to let that go, all the objects that fill my time.

You still come back to London regularly. How do you experience the city?
London has amazing pockets of landscape — Greenwich, for example, or the Serpentine Pavilion. It's so beautiful to see that in the centre of such a big city.

Before we moved to Goa I would always rush, but now I really try to see the city and observe it carefully. Why is this here and what happens when I see this landscape, how does it make me feel? Now I understand the importance of nature in everyday life.

What are your plans for the future?
We want to do more self-initiated projects, which is what was missing for us in London. Vikrant and I are tired of creating a vision for somebody else. Living here in Goa helped

us shape our vision of how cities need to be designed to adapt, change and grow. So why not develop a project for ourselves and find investors for that? That's our next step.

→ STUDIOAMITAVIKRANT.COM

PREVIOUS SPREAD LEFT Nature, and its cycle of growth, decay and regrowth, has started to shape the couple's architectural thoughts. They aim to create a dialogue with nature rather than moving away from it.

PREVIOUS SPREAD RIGHT The two architects work across multiple scales. This lightweight plywood bench is made with interlocking joints without any glue.

TOP Along with sea and sand, Goa is equally famous for its historic churches and Indo-Portuguese buildings found across the state.

MICHAEL WICKERT fish smoker, founder of Glut & Späne

'There are a lot of very fancy, artisanal products out there that are often too artsy for the rural population. I don't want that. My products should be for everybody'

Berlin → **Gerswalde, Uckermark, Germany** population 1,000

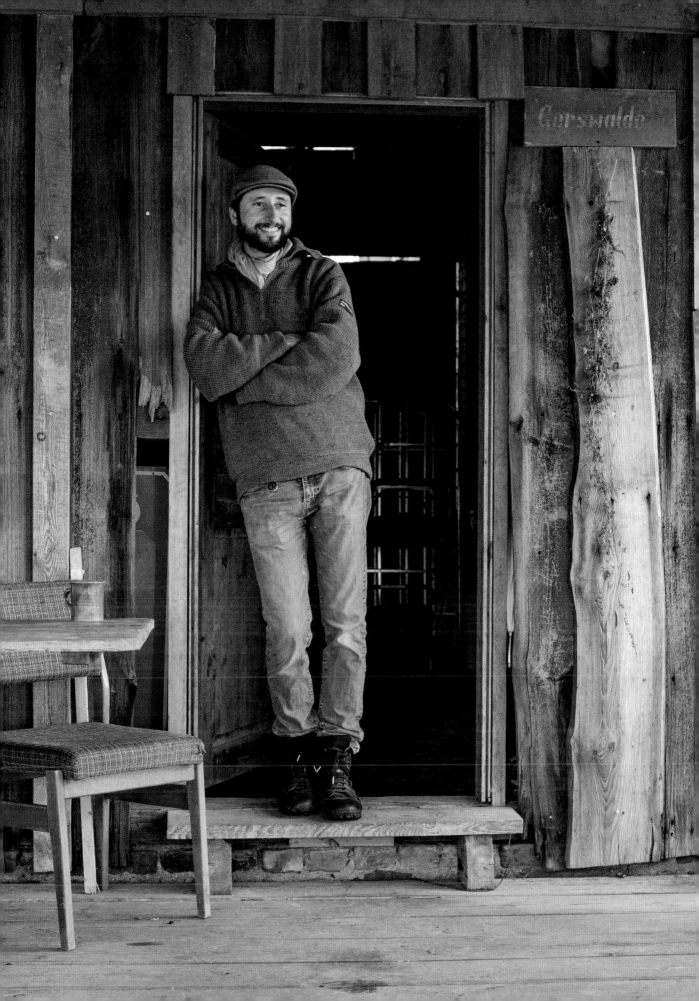

Growing up in the south of Germany, near Lake Constance, MICHAEL *was given his first fishing rod at the age of six. He then studied fishery science in Berlin, and after a short stint in charge of a trout farm in France, came back to the city to open a food stall. Now, after 2 years of planning and preparation, Michael has realised his dream of opening his own fish smokery in the countryside. Operating from the grounds of an old castle plant nursery, his simple, high quality, sustainably smoked fish attracts customers from across the country, and is helping other local businesses connect with new audiences, too.*

What made you want to move to the countryside? We were running a food stall at Markthalle Neun, a popular food market in Berlin Kreuzberg, for almost 5 years. We had a lot of fun, and it was really successful, but something was missing for me. I wanted to be closer to the fish and, ideally, be able to catch my own fish.

I remember watching this documentary about the local area we're in now. I have been coming here for more than 15 years, and since I was a student I have dreamed of being able to work here as a fisherman and smoker. There was this moment when it suddenly clicked: a smokehouse in the countryside — that's what I want.

At that point I still thought we'd keep our stall at Markthalle Neun. I would smoke the fish here, and then just go back and forth. When I started looking for a suitable property I thought, 'why not go completely rural?' I would

be able to go fishing or forage for mushrooms after work, just as I used to do as a boy.

I think when you move to the countryside the city becomes interesting again. And vice versa, living in the city made rural life very attractive to me.

When did you move? I moved in March 2016. I live on a farm that belongs to some friends of mine. They run a permaculture farm and teach workshops. I still have a small flat with my girlfriend in Berlin — she's a graphic designer and is more tied to the city — but she is also thinking about working remotely in the future.

After 2 years of prep work I finally opened the smokehouse a couple of weeks ago. A lot of my customers are from Berlin — many come out here for the weekend — but I'm able to attract the local crowd as well. I've already taken part in the village fete twice. The locals appreciate that something new is happening. There are a lot of very fancy, artisanal products out there that are often too artsy for the rural population. I don't want that. My products should be for everybody.

Of course, I also sell my fish to restaurants in Berlin. I'm part of a food distribution platform called Marktschwärmer, but I don't just want to sell to Berliners. I knew that the smokery would work in the city. But transferring the idea to a rural environment provides different challenges — making a living here is not that easy. However, I noticed that there is interest from the media already. It is becoming a bit of a thing to move out of the city. There's this pioneering spirit.

Did you know anyone before you moved to this area? No, I didn't. I've been looking for the right place for a very long time. In 2015 I spent a year on a local campsite and checked out all the villages in the area. I talked to a lot of people, just to see if there were any opportunities.

PREVIOUS SPREAD Michael enjoying the end of the working day at the farm.

RIGHT Tools in the smokery: beech wood chips, buckets and a fire-extinguisher. Pictured above are typical fish species native to the Baltic Sea.

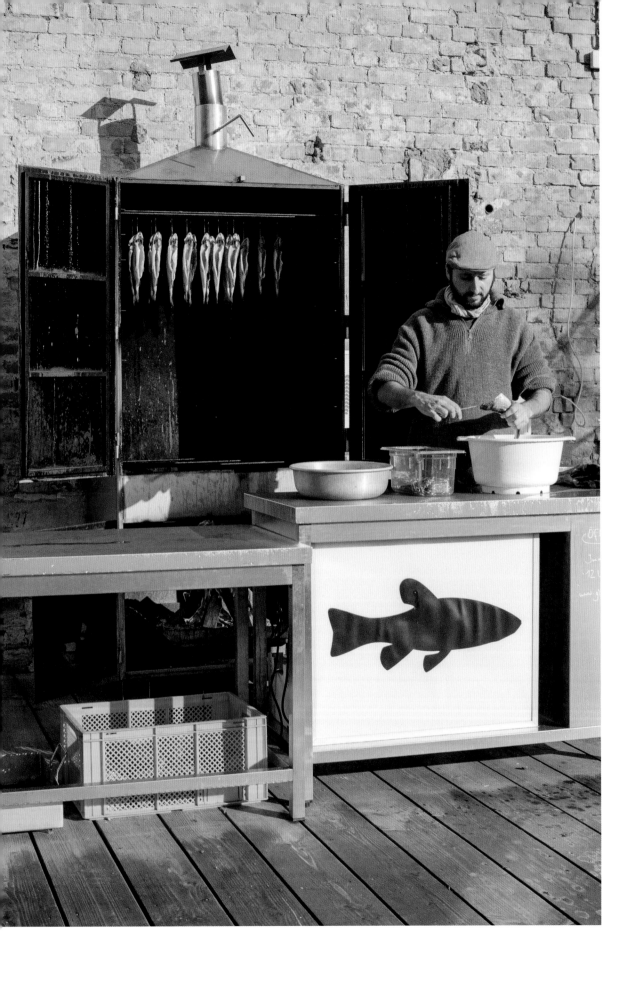

I met this couple who had just bought a big site that used to be the garden of an old castle. They kind of tempted me to move. I will never forget when we first viewed the site. There was a small building with a chimney, it had been used to heat the conservatories. When I saw it I was like, 'this is it. This is going to be the smokehouse. I can stop searching now.' I knew it was going to be a lot of work and take a long time, but it was totally worth it. It's a new beginning.

Do you do everything yourself? I get some help from my sister with social media. It's important to let people know I'm here. They need to be able to find me. My girlfriend helped me with my website and graphic design – two things I can't do. I'm good at smoking and talking about fish [laughs].

It's a little family venture. I want to remain small and be in control. I also want to keep doing the smoking myself. That's really important to me. In Berlin that wasn't really possible anymore. At times we had up to six employees.

My ambition is to also catch some of the fish myself. I'm a professional fisherman. There are over 500 lakes in this area and I'd love to start my own little fishery. At the moment I source my fish from local fishermen and that's great, but hopefully I'll be able to get a lease on a few lakes. Some of them belong to the World Wildlife Fund, but they allow sustainable fishery. I'm already talking to them so it's all looking good.

It sounds like the locals have really embraced you and your business. Yes, they really have. Funnily enough there's a small fishery museum in the village, which is run by a local club. I became a member and help to curate the museum now. Every time I run one of my smokery courses I also take participants to the fishery museum. It's been a great access to the village community.

Newcomers in a small town can face resistance from the local community. How do you feel about that? I think that's often the case in rural areas. But somehow I manage to attract both crowds: people from Berlin think it's really cool, having this fresh approach to something quite traditional like smoked fish, and the locals like it as well. It's a product that everybody understands.

Talking about fishing is such an ice-breaker. Last year at the fete I had a conversation with an old guy from the village about a special fish variety called tench that's fallen into oblivion. He was familiar with it. I told him about my plan to pickle some.

A similar thing happened with my neighbour who was recommended to me for a tiling job. People here are usually very quiet and introvert, but as I started talking to him it turned out he owns about nine fishing boats at various lakes in the area and has a shed full of fishing rods. Now we go fishing together. Even if we don't agree about politics, with fishing there's always a common ground.

I think food in general is a great way to get talking to people. It's a great conversation starter. I'm naturally introverted, but talking about food always works. You just have to make the first step.

It's really positive that people like you bring fresh ideas to rural areas. Many people dream about doing it, but it's easier said than done. I often have the same sorts of conversations where people go: 'Amazing, you're working in the countryside, that's what I want.' They have this romantic idea about rural life, so I try to put it in perspective. It can be hard to make money or you might not get on with your neighbours. Winters here are dark and grim. It's bad in Berlin, but here you feel it much more.

But it's definitely a very current desire. People are a bit tired of the city and are thinking about moving.

Do you stay in touch with the food scene in Berlin? I'm always on the lookout for new restaurants and places in Berlin. I know a

LEFT Michael prepares trout for smoking.

NEXT SPREAD LEFT Michael carefully composes his woods for smoking, picking different combinations depending on the fish variety. He also uses a cold-smoking process for sea salt. The salt is smoked in beech wood chips over several days.

NEXT SPREAD RIGHT Smoked trout – ready to be served.

I LIKE FISH

MICHAEL WICKERT 'Fishing is a great way to enjoy nature. No talking, no interference. Some people meditate, I go fishing'

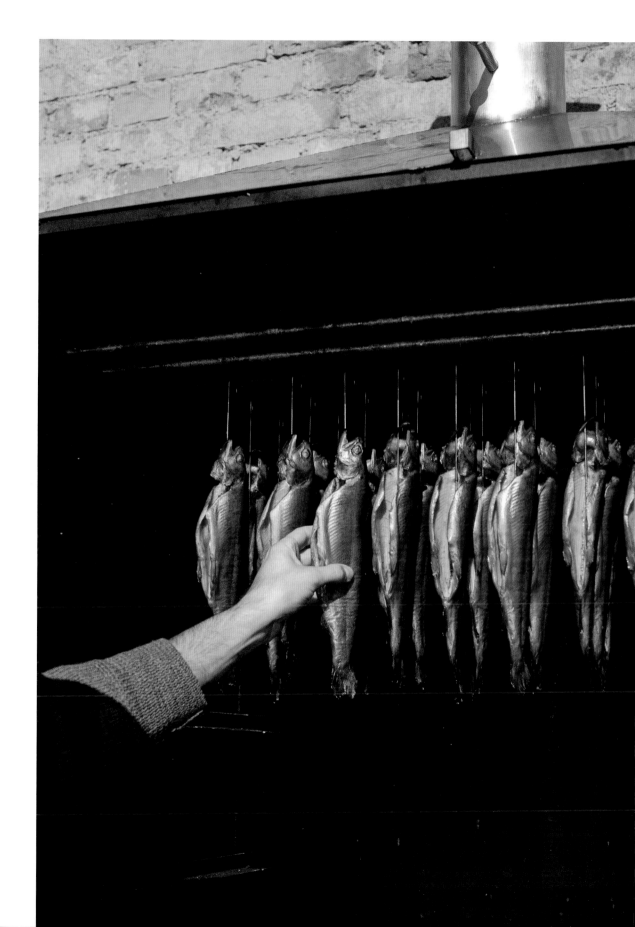

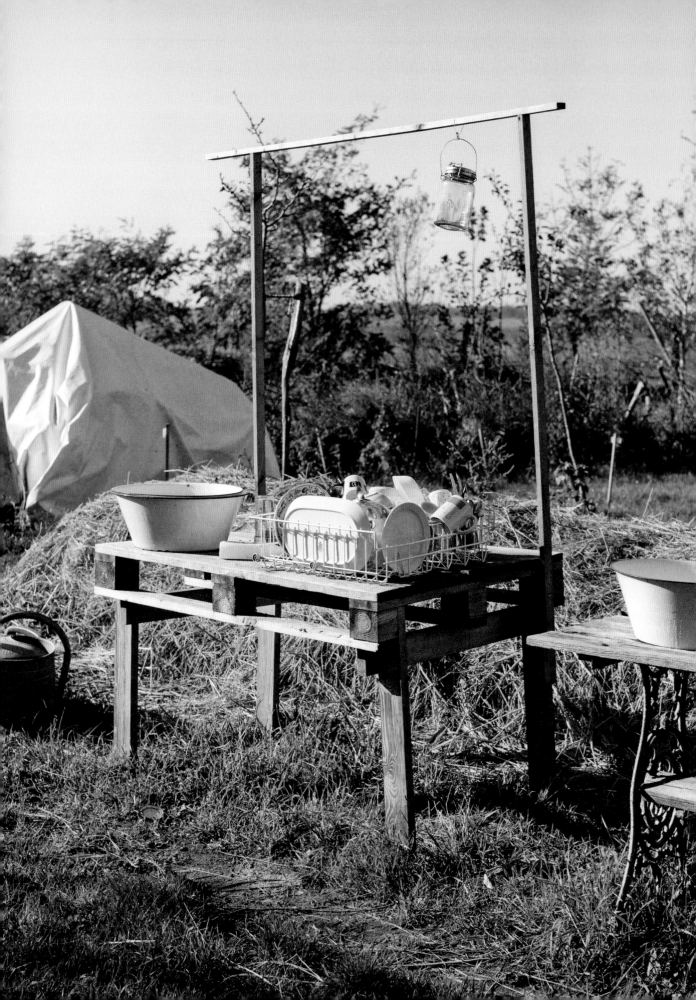

lot of people in the food business, and I have conversations with them. I'm also really into wines. I wouldn't say I'm a connoisseur, but it is another hobby of mine. I love visiting local winemakers. In my next life I'm going to be a winemaker [laughs].

Do you serve food here as well? Yes, I have a little courtyard snack bar that's open on Saturdays. That has always been my dream: serving fish fresh from the kiln, with a bit of salad or pickles on the side. I offer some local wines, too. It's simple and affordable.

I like being a host without having a whole restaurant to take care of. It has more of a pop-up atmosphere.

What do you do in your free time? Sometimes I do go off into the woods to look for mushrooms or I go fishing. That is a big part of why I've chosen this life. It takes me back to growing up. That's what I used to do as a little boy.

Fishing is a great way to enjoy nature. No talking, no interference. Some people meditate, I go fishing. I know now how important that is — especially because I need to talk a lot in my job. Sometimes I go camping for a couple of days. It's a real quality of life for me, it makes me happy.

I like being spontaneous. I have a VW van which has all my fishing rods, a sleeping bag, and a small bed. It's ready to go. I don't need to plan or pack, I can just hit the road whenever I feel like it. I can be by the sea or in the woods in an hour.

I also want to explore more of my local surroundings — the Baltic Sea or across the border in Poland. It's a whole different landscape; all these things that I didn't get to do in the last couple of years.

How about your social life? Have you found a lot of like-minded people here? The evenings here are actually one of my favourite

LEFT Outdoor dishwashing station on the farm where Michael lives.

RIGHT The 'Palmenhaus' nearby is used for workshops and as a pop-up coffee shop.

things. The farm is a great place to hang out. They have a campsite where people who come for the permaculture workshops stay, so there's always someone around to chat to. It's like having a local pub.

We often have a bonfire, too. I love it. I can switch off completely — it's like a mini holiday.

Do you feel your conversation topics are different here? Yes. In Berlin people talk a lot about work. Here people talk about all sorts of things, work is not that important. It's much harder to switch off in the city. It takes conscious effort to shut everything down. Here you can just sit and enjoy the scenery.

Could you imagine giving up your flat in Berlin to be here permanently? Oh yes, definitely. At the moment my girlfriend still needs it as a base. But I could definitely give up city life.

It's not that I don't enjoy going to Berlin. It's nice to have it close by, but it's more relevant from a professional point of view.

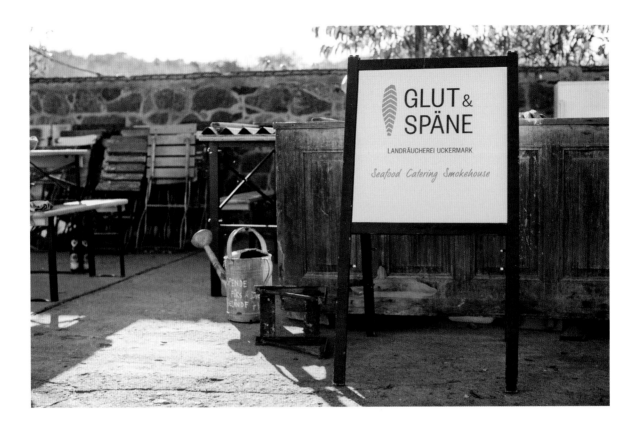

Do you think working in Berlin gave you an advantage with setting up your business here? Running the food stall definitely helped me. I know how to connect to my audience, whereas the local hunter might have the best meat but doesn't know how to sell it. In Berlin there's a huge demand for things like quality sausage, venison and game, but you need to know your audience. There are so many businesses here that totally miss that link. In the city there's the demand, and out here you have the produce, but there's no connection. I'm sure that is going to change in the future.

Some people call me the 'Uckermark ambassador'. Whenever people visit me I try to take them to some of the other producers in the area. There's a guy who makes excellent apple juice and cider, a hunter, and an oil mill. I want people to see all the amazing products we have here. The idea is to promote the region as a whole, and also businesses that don't have a good website or the tools to sell their products.

What are your plans for the future? Finish the smokery, and make a good plan to tide me over for winter. For the rest, I'll just wait and see. I'm very proud and happy about how it's been working so far. In a way, everything turned out how I have always imagined it.

Another ambition of mine is to bring back some fish varieties that have become unfashionable or forgotten, like tench. It's not easy; you need to make people aware of it.

And it's not official yet, but I recently decided that I want to make tinned fish with an old tin machine. It's a great conservation method, and makes a great gift. Nobody else is doing it apart from one guy in Austria. Usually you only get tinned marine fish, so that's another thing I'm excited about.

TOP Michael's courtyard snack bar is open for business on Saturdays. Being able to serve fish fresh from the kiln with some pickles on the side, and maybe a glass of local wine, is a 'dream come true.'

RIGHT There are more than 500 lakes in the local area, and Michael hopes to soon acquire a lease permitting him to fish here.

→ GLUTUNDSPAENE.DE

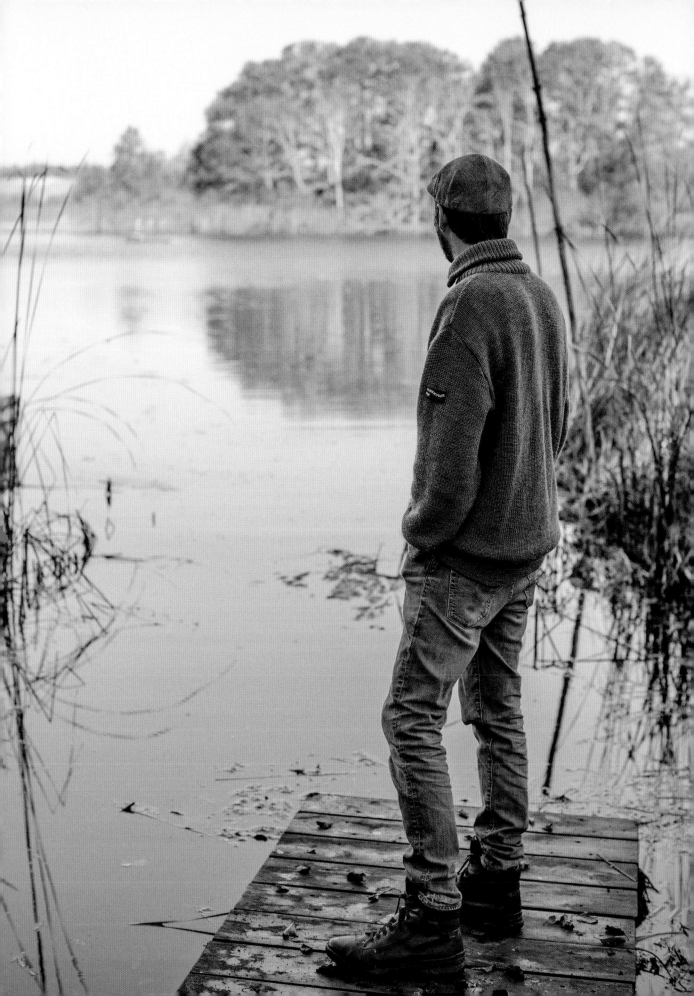

BRIAN BOSWORTH ceramic artist **& JAMIE POOLE** shopkeeper

'For me, part of self-sufficiency is also this idea of being in control of your own life, being your own boss'

Los Angeles → **Joshua Tree, California, United States** population 7,400

When BRIAN, *a ceramic artist, and his partner* JAMIE *moved to Joshua Tree more than 10 years ago, they pulled out of all the systems that made life in Los Angeles difficult — the impenetrable art world, the education and the medical system, and the housing market. In the middle of the High Desert of California, they were able to create a more family-centred lifestyle and home-school their kids. It wasn't an easy ride, and Brian still occasionally struggles with the claustrophobia that can come with living in a small town. But leaving the confines of the city and all its pressures allowed him to develop a unique style of functional ceramics, a more self-determined way of life, and a happier place to call home for him and his family.*

What was your motivation to move to Joshua Tree? BRIAN BOSWORTH: After I graduated I had a go at the LA art scene. I was trying to show work and teach art classes in desert cities to support us. I was commuting out, driving most of my life basically, sometimes up to four campuses, 1,000 km a week. Needless to say I didn't get very much art done.

In 2007 they were selling the house we were renting in LA. It was at the height of the market and we couldn't afford to live in LA anymore. I was already teaching down in Palm Springs, so location-wise it made sense to be here. It was less time to commute. However, I think Joshua Tree made more sense for Jamie.

JAMIE POOLE: Joshua Tree just kept coming up, there was something about it. It was a very intuitive decision. We had two young boys, they were three and seven, and our older son was struggling in school. At that time he was diagnosed with Asperger's. He's very smart and was testing very high, but he didn't receive the care he needed. I wanted to move to a place where we could live on one income and home-school the kids. We basically pulled out of everything to address our son's needs. Around that time Andrea Zittel had a big show at MOCA [The Museum of Contemporary Art, Los Angeles]. I was blown away. Her work was all about self-sufficiency and basic needs. She is also based here in Joshua Tree, so there was already some creative activity going on.

BB: In the first year I didn't like it. I didn't want to live here at all [laughs].

Why were you hesitant to move out here? BB: I had left LA, and that's where the art world is, right? All the people I talked to were like, 'this is career suicide. Why would you move out to the desert?' That first year was really freeing. I wasn't influenced by what anyone else was doing. I had no expectations and it actually led me to do some better work.

How has it been so far? JP: We were here for a year and a half and then the housing bubble burst. We were able to buy a three-bedroom house with a swimming pool that we never could have afforded anywhere else. Our sons have both really thrived out here, so that part has been awesome for us.

BB: It's a complicated question. There are pros and cons. We would never be where we're at if we didn't live here, and I'm grateful for that. It just freed us up to say 'yes' to things and take risks. We've been able to do things, you know. At the same time it's a very suffocating environment. It's a small town, everyone knows your business, or believes they know your business. It can become a little too much sometimes.

JP: Yeah, we're trying to get out more. Luckily we're at a place in our lives where we can actually go on vacation. We just took our kids to Costa Rica. It was awesome and so needed.

Did you find it easy to connect with the local community? BB: Joshua Tree is changing a lot, it has become more popular and touristy. The magazines are romanticising it so much. People are buying property out here just to capitalise on it and don't actually live here. It feels a little exploitative.

Whereas I feel we moved out here and made our way up. We paid our dues. We were the first ones to bring this kind of aesthetic to Joshua Tree. The other art at that time was very tribal

PREVIOUS SPREAD LEFT Life in the desert inspired Brian to explore functional ceramics. His signature style of geometric planters is now selling in stores from London to Tokyo.

PREVIOUS SPREAD RIGHT Moving out of the city allowed Jamie to homeschool their two sons and provide a level of care they couldn't attain in LA. Now their kids are thriving, and Jamie and Brian run a successful business together.

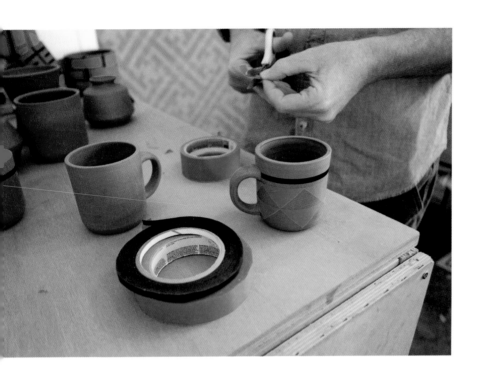

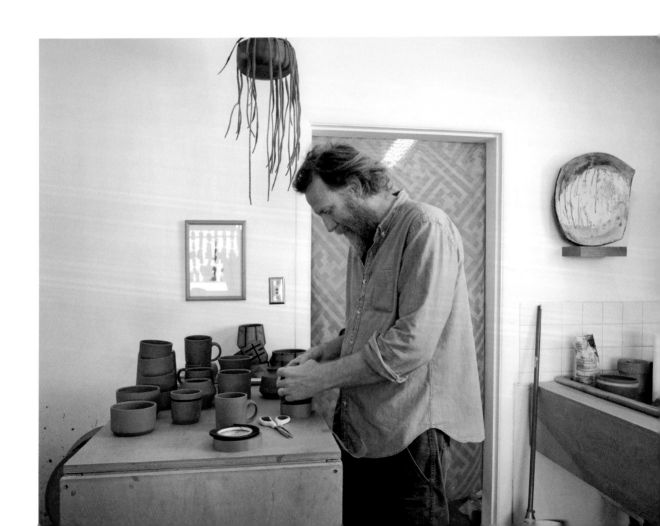

with lizards and coyotes. When we opened we brought in other designers from LA that weren't your typical kind of desert ceramics. It wasn't well received at first, but we just didn't go away.

JP: There's something to be said about resilience. We've seen a lot of people come and go.

BB: This town is famous for people coming here with brilliant ideas and then they're gone. It's hard to make it here.

How did you get into functional ceramics? BB: Doing sculpture out here just seemed ridiculous. Why make this sculpture to sit in my studio, cart it down to a show in LA, and then bring it back? The sculptures I made weren't selling, either. The simplicity of living out here brings practicality. The focus is different. You start noticing things differently than in the city: the textures and the feel of things, colour or the absence of colour, and the subtlety of colour. I was doing slip casting, so I started blending the idea with planters. With the help of Andrea Zittel I started selling these planters and it just sort of took off.

JP: The geometric planters in particular were selling really well. Nobody was doing that back then. I put in an application for Dwell on Design, a design fair in LA. I thought, 'they're not going to accept us', but much to my surprise, they wanted us to come. We had 6 weeks to get it together. We busted out a kick-ass booth with Brian's work and people loved it.

BB: We were completely naive to the whole thing. People would ask us for line sheets and we had no idea what that was. We had no concept of wholesaling. We were just selling off the shelf. Just having honest work and an honest booth, I think that's what people saw. Everything else was so highly manufactured. All of a sudden we were featured in magazines. It was a big boost.

LEFT The demand for Brian's functional ware has been growing steadily. The couple is looking to move the studio to a bigger space, so they can hire staff to help with production.

NEXT SPREAD LEFT The desert has always attracted a particular crowd of creatives. Although Brian and Jamie sometimes struggle with the commercial exploitation of Joshua Tree, they still feel a sense of reverence for nature every time they go for a walk in the nearby national park.

JP: There was a space available here that we could use as a showroom for very little money. We were doing art installations and events, and also brought in other handmade items from people we connected with.

BB: We just fell into it, but part of that is because we moved out here. We would have never done this in LA. We would have never even tried it.

Why not? BB: In the LA art world you function in this bubble and you don't go outside of it. That's how people think. Coming out here you realise that it is ridiculous. Going back and talking to artist friends in LA you see that they are still in that bubble, they still function according to those rules. It is weird to see how controlled that environment is. You are supposed to be the creatives, the artists, yet you only function within this bracketed system, and you can't even see out of it.

After Dwell on Design we did really well a couple of years in a row. I started doing functional, wheel thrown stuff. That's what everyone wanted – mugs, plates and bowls. I never really considered it as something that I wanted to do. I kind of got into it and that's where we're at right now, functional ware and learning how to run a business [laughs].

JP: It's just been real. We didn't take out any loans, we're just building super slowly. When this site here came up for rent, we were asked to do a pop-up. It worked, and now it's our permanent shop.

BB: I've been super busy keeping up with the growing demand, but I've been able to systematically reduce all those adjunct teaching jobs to just one here in town. That was part of the goal, to get out of teaching and stop commuting. For me, part of self-sufficiency is also this idea of being in control of your own life, being your own boss. The idea of having no obligation unless I put that obligation on myself.

Joshua Tree has such a big presence on Instagram. What's your approach to social media? JP: I think Instagram is a huge part of the claustrophobia we feel. It is a great business tool, but we're inundated constantly. You have to have clear boundaries, otherwise it will just suck you in.

BRIAN BOSWORTH 'In the LA art world
you function in this bubble and
you don't go outside of it. That's
how people think. Coming out
here you realise that it is ridiculous'

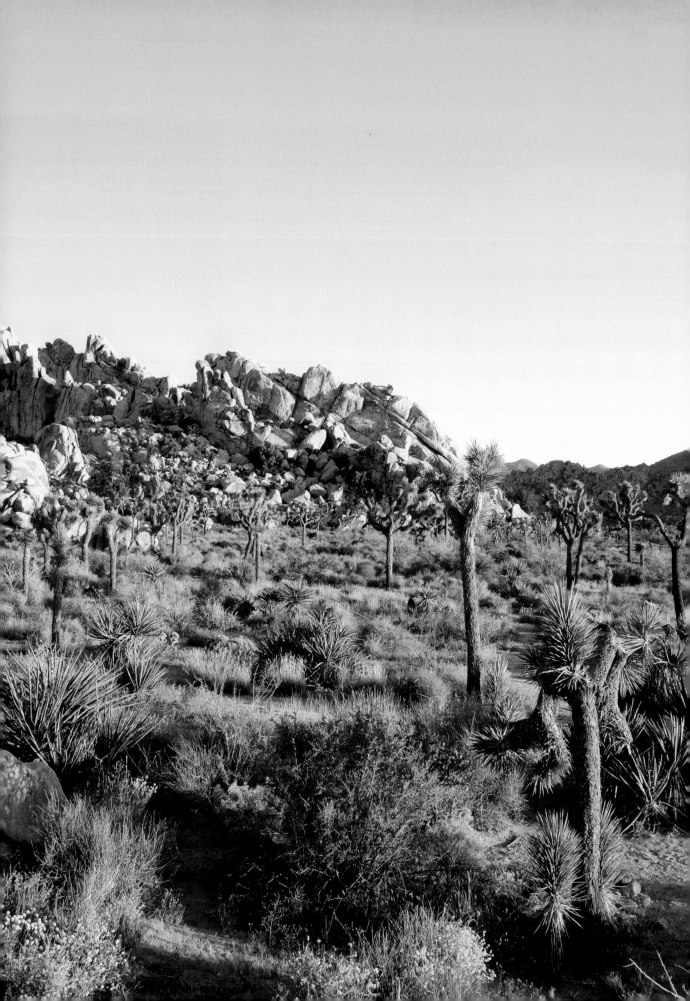

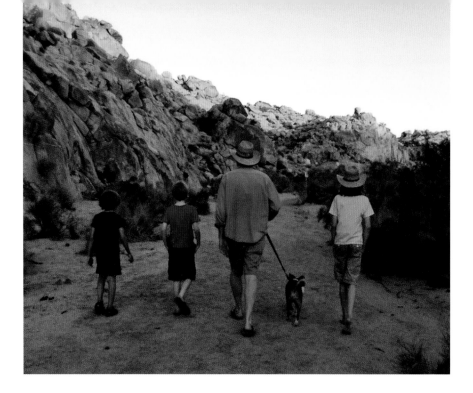

BB: I think it was Urban Outfitters who came out here years ago. Then the New York crowd came out and explored Joshua Tree and, boom, it just exploded. It has become a strange obsession, a romanticised notion.

Do you use Instagram for your business? BB: We use it in a very minimal way, to post new work or an upcoming event. There are no pictures of our personal life. It just seems weird to me. I think it's such a big contradiction these days. Rather than just enjoying something, people share it: 'Here I am relaxing in the hot tub.' You're not relaxing, because now you have to check how many people liked you relaxing in the hot tub.

JP: Luckily that's not everybody, and eventually people will be oversaturated with everyone else's experience of nature.

Do you spend much time in nature? JP: Initially being in nature was a big draw for me. I needed it. We're at a point again where we really need to reconnect with that. We've been

so busy keeping up with the business that we lost touch with it.

BB: Maybe you take it for granted a little bit, but whenever we go for a hike behind the house we're just blown away. It's amazing every time. There's still that reverence for nature. It is so quiet out there, you kind of fall in love with that.

What are your plans for the future? BB: We have another property we want to fix up. We want to build a studio there so we can expand a little bit and bring more people in to do some work.

JP: Maybe we'll open another shop somewhere else. Our kids are going to college soon and our older son is going to need extra support, so again, we're probably going to follow our kids. He needs to get out into the world, see some other things.

BB: I want to get back into sculpture. I'm feeling that pull, and I need that freedom again. It is good for my own wellbeing. I want to keep that alive. I do have some things in the shop that are more creative – they sell for quite a bit more. At the same time the demand for the functional ware just keeps growing. If I could combine the two it would be great. If there's ever a day where I don't have to make another mug I'm happy [laughs].

PREVIOUS SPREAD RIGHT Their BKB Ceramics store in Joshua Tree stocks a carefully curated selection of locally produced items – ranging from olive oil to jewellery.

TOP The path behind their house leads to a formation of boulders covered in petroglyphs.

→ BKBCERAMICS.COM

BARBARA AMBROSZ designer, co-founder of Lucy.D

'Connecting global thinking to local production is something I want to explore more'

Vienna → Paris → **Sierning, Upper Austria, Austria** population 9,200

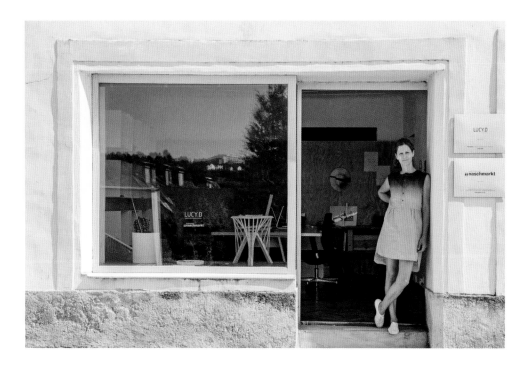

BARBARA *is the co-founder of design practice Lucy.D — an award-winning studio with the motto of 'revealing the poetry in everyday life'. Seven years ago, she left Vienna for a farm in rural Upper Austria, where she lives with her husband and two young children. The contrast in lifestyle was tough, she admits, but the freedom, lack of distraction, and unspoiled surroundings of her new home all contributed to a grounding experience that changed her, and her work, forever.*

What made you want to leave Vienna? Love! [laughs]. My husband Hans is a farmer and is bound to this location. I've always had a close affinity with nature — it's definitely something that has shaped me. When I got pregnant, I decided with my business partner Karin that it would be the best solution for me to move here. I left for personal reasons, but it was also a crucial decision for our business. We had the confidence it would work out and I believe it enriched our profile.

How has living here affected you? Being able to work in a different environment, especially in a rural one, gives you a lot of freedom. There is less distraction — no street noise, less appointments and meetings. Your eyes just have a totally different horizon here. I'm surrounded by fields. If I step outside I can see green for miles and miles with nothing blocking my sight. In Vienna, or any other big city, there are always walls in front of you.

I have been living here for 7 years now and it has definitely changed me as a person. I'm much calmer. I notice the different seasons, different times of the day. It's a very grounding experience. I think in the city you can lose your grip — I don't mean that in a bad way — but it's easy to lose your connection to nature, your roots.

It's interesting to see the effect the rural context has on people who work creatively.

PREVIOUS SPREAD RIGHT Barbara left Vienna to live with her husband on the family farm when she fell pregnant with their first child. The move has made her feel more grounded and, surprisingly for her, greatly benefitted her creative practice.

TOP Barbara's studio in nearby Steyr is located in a beautiful, historic building in the centre of town.

LEFT Prototypes for a new collaboration with a local porcelain manufacturer — combining a contemporary, modular approach with traditional production techniques.

I'm discovering new things about myself. If I feel stressed or unwell, I go outside and do something with my hands. I do that a lot in my job anyway, building models, experimenting with materials, but to really get stuck in with your hands in soil is something else entirely. It really affects you, in a positive way. Then I realise my thoughts are shifting as well. I think nowadays this sort of grounding is something absolutely essential and necessary. It makes it easier to stay true to yourself; you are less influenced by trends. I think it has really improved the quality of my work.

Did the move to a rural environment change your design process? I'm really interested in bringing new technologies and craftsmanship together. Connecting global thinking to local production is something I want to explore more.

At the moment we are doing a project with a local brand called Neuzeughammer, which I am very excited about. It is one of the last remaining porcelain manufacturers in Austria, and we are working on a new range of lamps. It's a modular design based on 5 simple geometric shapes in ten colourways that can be combined, offering endless variations. They feel equally fitting in an urban as well as in a rural environment.

How often do you go to Vienna? About once a week, and I love it. If I stayed here all the time I would probably get cabin fever after a while, so these small doses of city life are a real bonus. But days are quite intense there, with meetings and teaching, so I'm always happy to come back here. I also have a studio space in Steyr, a small town nearby.

How does your company cope with being based in different locations? We've been working together for 13 years. Karin spent 2 years in Italy, so we've been even further apart and it worked just fine. Today, methods and possibilities of working together are just so diverse – it's like a relationship. You can have a relationship in many different ways, why shouldn't it apply for work as well? The key is to have a partner you can trust. And I think in a long work relationship it is important that

people evolve. Otherwise it gets very boring. Just like a romantic relationship, you need new challenges, new projects.

What does your husband's routine look like? It depends on the season. During winter it is quiet, and then in spring and autumn it gets very busy. He ends up working every weekend. It can be quite challenging for family life. I really had to get used to this lifestyle. But living on a farm offers you a completely new perspective. I think that's why I work as a creative – I'm curious about life. I used to do a lot of travelling and that was how I got my insight into other cultures. Now I travel a lot less, but living here gives me a new outlook on life. I'm learning something new every day.

How did you adjust to life on a farm? Getting settled here wasn't easy. Having a baby is challenging anyway, but I was new here and often felt quite lonely. Hans wasn't so connected to the locals either, because he had not been around much the last 10 years. He was working here, but always stayed with me in Vienna. He used to DJ and we spent the nights partying.

I kept my flat in Vienna for quite a long time after moving here, for about 4 years. I wouldn't have been able to just pack up and go. I really needed that anchor.

You mentioned that building networks is something that is really important to you. How do you approach that? I realised quickly that isolation doesn't work for me. I think as people we crave communication and connection with others. With the farm we are in the fortunate position to have a lot of space. We can create platforms that connect people. The Food Cooperative was a test pilot. Being able to bring people to the farm again and facilitating an exchange through food has been amazing.

PREVIOUS SPREAD The old barn is used for parties and events, and the occasional DJ session by Barbara's husband Hans.

RIGHT The switch to organic farming methods had a hugely positive effect on the family. A rediscovered interest in food and provenance led Barbara to establish her food cooperative – a self-organised community of households and organic farmers that helps distribute local produce.

BARBARA AMBROSZ 'With the farm we are in the fortunate position to have a lot of space. We can create platforms that connect people'

What made you want to start the Food Cooperative? One of the main reasons was to simplify the distribution process. The farmers around here produce a lot of great quality food, but I have to get in the car and drive from one to the other to get it all. You waste a lot of time driving around. Secondly, we met a lot of interesting people in the area that I didn't know about. One of our new members is a cook who spent a lot of time in Berlin. He was one of the first to do pop-up kitchens in Vienna. He has all the equipment, so I was immediately thinking about a collaboration. He lives in Steyr and was extremely excited about our space here and what we're up to. I like that we attract like-minded people who want to get involved.

The Food Cooperative completely changed my consumer behaviour and my attitude to food. It really made me think about what is important in life. For me it's about being able to evolve and grow, without leaving too much damage behind.

Has living here changed your attitude towards nature? I'm a lot more knowledgeable now. I learned a lot from Hans. When we shifted to organic farming last year we were all really excited about it. It affected everyone living here,

our whole environment. You realise that fertilisers and pesticides are toxic. You really notice when you remove that element. It has to do with aura as well — nature can be something almost spiritual. That's probably why creatives are drawn to nature and rural life. You rediscover this connection to nature again, something that is only partially possible in the city.

What are your plans for the future? I would like to stay here. This place has so much potential. Hans and I are big fans of Harald Welzer, a German sociologist. In his manifesto he talks about building 'laboratories of the future', promoting a grass-roots movement to design and test responsible and sustainable ways of living and working. That's something we firmly believe in. And I think this is the right place for it.

→ LUCYD.COM

PREVIOUS SPREAD Hans is equally passionate about sustainable farming methods as he is about music. Together the couple are keen to provide platforms to connect people, exploring alternative ways of living in the future.

TOP A photo of Hans' great-grandparents alludes to the rich family history of the farm.

CARLA PEREZ-GALLARDO & HANNAH BLACK
artists, chefs, founders of Lil' Deb's Oasis

'The community in Hudson is all doers, whereas I felt like my community in New York was full of planners or talkers'

New York → Madrid → **Hudson, New York, United States**
population 6,400

HANNAH *and* CARLA *both worked on the New York restaurant circuit at the same time as trying to establish an art practice. Struggling to find their niche in the narrow confines of the city's art scene, they soon found themselves in Hudson. Home to a tight-knit community with an open-minded atmosphere, it proved the perfect place to freely combine their passion for food and art in one creative endeavour. Their story illustrates that the move to a smaller town is not always driven by a desire to reconnect with nature. For them, the appeal was the creative freedom and the ability to thrive independently outside of larger systems on a smaller budget.*

What brought you to Hudson?
CARLA PEREZ-GALLARDO: I landed in Hudson when I came back from Madrid, where I lived for a year after college. Hudson was more accessible than New York City, and I felt like there was room for me to do what I wanted to do. The community here is made up of a lot of people who try to find their way outside of the norm. I felt potential in Hudson, which is why I stayed.

HANNAH BLACK: I moved to New York after college because that's where everybody went. It was the centre of the art world. I lived there for 5 years and worked in various jobs. I loved it, but I also kept questioning if this was really where I wanted to be.

Then my best friend from college moved to Hudson. I came to visit her a lot and just had the best time. Her community in Hudson was all doers, whereas I felt like my community in New York was full of planners or talkers.

I went to South America for 6 months and got really into this idea of wanting to work with food. When I came back, I moved to Hudson. It just made a lot of sense — it was easy. I started running a food truck, and that's when I met Carla. We did catering projects together and eventually opened a restaurant, which never would have been possible in New York unless we had some big investors. It all happened very fast and serendipitously.

When did you open your restaurant?
HB: About a year and a half ago. We had saved some money from catering, and had a little bit of help from family and friends, but it was so low budget. And we did it in a month.

CP: It felt very much about Hudson, you know. Being able to put together this passion project that, just a year and a half later, is a very real business that's thriving in many ways.

HB: When we were doing the demolition and the construction we were able to call upon this crew of friends who not only had skills, creativity and vision but also the freedom to jump on board our project. We didn't have money to pay them, we just offered them free food. But they had the time to come in and help us renovate the space. We couldn't have done that in the city. All my friends there are working three jobs and would never do anything for free.

What is it about Hudson that attracts people like you? HB: I think it's a combination of things. Location is pretty crucial. It's 2 hours north from New York City on the train, so going back and forth is easy if you do creative work that requires you to have meetings in the city.

It's also beautiful. It's surrounded by rolling hills, and across the river there are waterfalls and mountains. There is a really fun, young, creative crowd of dancers, filmmakers, musicians and creative artists here — a lot of people to collaborate with. And the stakes are not as high. You know your rent is not crushing you down like in the city.

CP: People are often surprised at how vibrant it is and how much it feels like a city. One of the things that has kept me here was feeling like the dreams we have are possible in this landscape. It's still hard, and we still worry about money, but there's a way more tangible quality to life here. It feels so much more collaborative. It's how I have always imagined my ideal environment.

The way we're doing things is outside of the ordinary, outside the normal structures that

PREVIOUS SPREAD LEFT It is important to Hannah and Carla to be open and available to everybody.

PREVIOUS SPREAD RIGHT Hannah and Carla's passion for creativity and community underpins everything they do, and one of the reasons they were drawn to Hudson was the crowd of young creatives. Many of their staff have passion projects — something they wholeheartedly support.

RIGHT Hannah was running a food truck in Hudson when she met Carla, and the pair discovered a shared love for food and art.

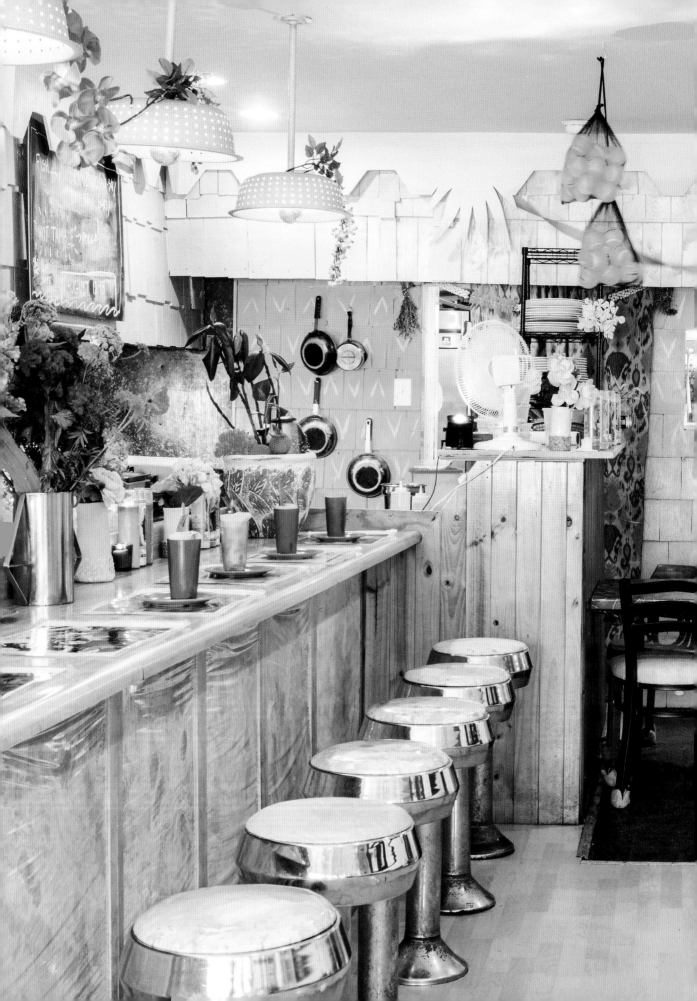

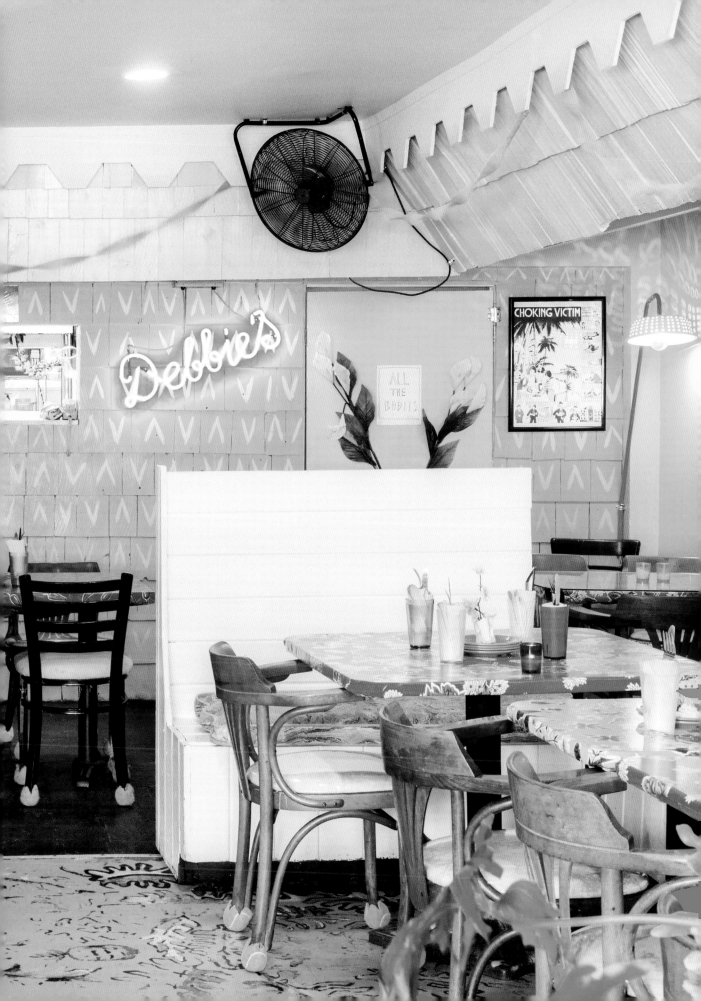

you need to employ in order to open a successful business in Manhattan. We were able to push our vision and keep that at the fore, as opposed to having all sorts of reality checks along the way, from investors to people limiting your voice. We had the opportunity to do it our way.

What was so different about opening a restaurant here compared to the city? HB: We opened with no money and we opened really fast. We had the idea in January, we were offered a space 2 weeks later, we signed the lease in April and we opened in May. That timeline is highly unheard of in the restaurant industry, and definitely not in the city. We opened without any debt or investors.

CP: We did zero promotion and just launched quietly. People in the industry warned us — where was our business plan and what was our 5-year model? All of these classic and very reasonable questions [laughs]. We were just like, 'look — we've been handed this opportunity and we're not going to say no. We're just going to take a leap and do it.'

HB: We're still learning as we go. It's definitely not easy. We work very hard, but we're also able to be open 5 days a week instead of 7. It's a much more civilised lifestyle. We work a lot but we also have a lot of fun. We can go dancing or do the occasional hike.

You said that Hudson feels like 'a community of doers'. Do you think people take more risks? CP: The cost of living is lower and people have more time to say 'yes' to things. You can say: 'Hey, wouldn't it be fun if we did this?' And then do it. Of course there is that ethos in New York and many things are happening, but it just feels like there is more time and space to make it happen here.

Do you miss the city? HB: We still go to the city regularly. We're so close, and we still feel part of some greater conversation about food and restaurants.

But now when I go back to the city I always get overwhelmed by the options. What I love here is that I know what restaurants are open on Tuesday night, and I know where everyone is going to be tonight, which bars have the most happening things going on.

How do you combine your art practice with the restaurant? CP: It's not isolated in the way it was. Both of those things coalesce within the space of the restaurant. It's always changing — whether it's the wall colour, the events we do or the dishes we put out. We do a lot of collaborations with other artists and create events together. We do food but we also have a hand in the space, lighting and music. It's another expansion of our studio practice.

HB: In a way the restaurant is our studio. We're constantly churning out ideas that we then take onto other projects. We often call it our think tank.

CP: Also, a lot of our employees have other projects going on. We love that. It's all part of what we want. There's a collaborative effort, it makes us a richer place.

HB: We try as much as possible to allow people to express themselves through this platform that we have created. I think other businesses stifle that in a certain way and suffer because of it. It's a lot harder to find good committed employees around here.

It sounds like Hudson is a pretty open-minded community. Do you ever encounter people who don't understand what you're doing? HB: Hudson is like a microcosm of a bigger city that has all kinds of ethnic backgrounds and levels — it's really diverse. It's not the whitewashed antique town that it's often painted as.

It was important to us not just to be this hipster, artsy place, but to be open and available to people that have been here longer than us. Our menu is quirky, and we don't do hamburgers. When someone walks in and seems overwhelmed or uncomfortable, we offer them a free snack. Some are unwilling to try, but we've been able to convert a few people.

PREVIOUS SPREAD The aesthetic of the restaurant bucks the more common 'rustic-modern' trend with a cheerful, tropical vibe. It's the space where all their creative talents coalesce, or as they describe it: 'an ongoing restaurant/installation/performance project'.

RIGHT Their colourful aesthetic also features in the food served at Lil Deb's Oasis, with a menu of 'tropical comfort food.'

CARLA PEREZ-GALLARDO 'The way we're doing things is outside of the normal structures that you need to employ in order to open a successful business in Manhattan'

Do you feel your conversation topics have changed since moving here? HB: In New York my community was all twenty-something, college-educated artists. We all orbited in the same circle, went to the same openings and the same parties. You saw the same people all the time. I think that was one of the reasons I was kind of bored or frustrated. In the restaurant our customers range from 9 years old to 70, from all kinds of backgrounds. Our community is so much larger and interesting.

CP: It feels good and engaging having all levels of experience and worldviews coming into one conversation. I think it's important to be challenged.

Has nature influenced your creativity at all? HB: I love and appreciate nature, but I'm more inspired by people and the conversations we have. A lot of the ideas we are coming up with these days are through conversation with our friends and customers. That's how the restaurant got started, through conversations. It's what kept us moving forward creatively.

Do you think it is easier to find your own voice being outside an urban metropolis? HB: We do feel part of a contemporary conversation with young chefs in New York and that's definitely cool. But we also have less of the pressures that they experience. There is a lot more media attention on the city. You get one bad review and that can crush the restaurant entirely. We have a bit more freedom to be weird or a little different.

I think less stress, less pressure, less rent to pay, a slower pace — all of those factors allow for more creativity for sure.

CP: There's intentionality behind what we're doing. We are very specific with our aesthetic. There are a lot of restaurants here that are very similar and have this farm to table, rustic, industrial look. We're very much not that. For this area we're doing something very, very different.

Do you think having lived in the city enabled you to bring something new to Hudson? CP: I don't think my 'cityness' is what is influencing what we're doing here. What I bring has more to do with growing up in Queens, which is extremely diverse, with many different cuisines. There is a richness of flavour, originality, and cultural crossover.

HB: I think living in the city did instill this sense of hustle. I'm not naturally competitive but working in restaurants you adopt a certain work ethic. It's sink or swim. You can definitely dial that down a notch when you're upstate, but I think it's not a bad attitude to have.

Do you feel you have more of an impact being part of a smaller community? HB: Definitely. In New York I never went to a town hall meeting. But living in a small town like Hudson, especially in this day and age with the government being so crazy, we constantly ask ourselves what we can do to make a change. With a small community the change you can make is tangible, much more so than in a city.

CP: Of course racism and classism exists everywhere, but it's more blatant in its forcefulness or in its immediacy here. It's harder to ignore. I think that does create a greater need to be active on the ground level.

What are your plans for the future? HB: Our lease here is up in April, so we're looking for a new place. We want to expand, do events and try to bring more people into our space.

CP: We're looking at a building where we would be renting alongside two or three other businesses that we feel close to and want to join forces with. It would allow us to create a more compound community space where a lot of different projects can exist under one roof. We will have to think about how we can keep our ethos, energy and intimacy, but also professionalise in certain ways. We want to have the infrastructure that can support the dreams we want to implement.

→ LILDEBSOASIS.COM

PREVIOUS SPREAD Although Hudson is surrounded by beautiful landscape, the pair's motivation for moving was community, not nature. All their creative projects, including the restaurant, started through conversations.

LEFT Hannah and Carla's unusual menu can be challenging for some locals, but they have converted many through the simple offer of a free snack: 'It was important to us not just to be this hipster, artsy place.'

LYNN MYLOU founder of A Vida Fausto

'I want to show that you can live a modern, comfortable life in a carbon positive, non-toxic place'

New York → Berlin → Amsterdam → **Cerdeira, Arganil, Portugal**
population 320

From her studies in New York to design agencies in Berlin and Amsterdam, LYNN *built a career in the creative industry — one of hectic deadlines, long hours, and high pressure. Inspired to take action and improve her personal life, she began to explore more eco-friendly ways of eating and living, a difficult task in a modern city. Her priorities soon shifted and, a few years later, she made one of her biggest decisions yet: to sell her apartment and establish a new, sustainable existence in Portugal, creating a space to experiment and inspire others to do the same.*

When did you start thinking about leaving the city? It happened gradually, and started when I lived in New York. Living in a western city and experiencing so much inequality and poverty made me really sad. I was taking part in an exchange programme at Parsons The New School for Design — an expensive school — and 20 minutes from where I lived in Brooklyn was a totally different world, with lots of violence and abuse. That started to open my eyes about society, capitalism, consumerism, and all these things.

I then moved to Berlin and worked for a creative collective called Mindpirates for 3 years. I was a perfectionist and total control freak, and was always operating at 200%. It was then that I started to make conscious decisions in my personal life.

I did a lot of research on permaculture and food production and hit dead ends with certain things, for example with energy suppliers or food. In a city you don't have the time to go to that farmer an hour away that you can trust, and you're so often lied to by corporations that green-wash everything. After a while I thought, 'there's nobody I can trust so I'll have to do it myself'.

How did you make the transition? I got a puppy who required a lot of attention, and had heard about a concept that suggested we're only productive for 3 hours a day, so I thought I'd do an experiment and try it. The projects still

PREVIOUS SPREAD LEFT Lynn has adopted a strict plant-based diet, but keeps piglets to help improve the soil. She follows a natural farming philosophy, with limited human intervention.

BOTTOM & RIGHT Lynn built her two-storey accommodation, called 'The Birdhouse', completely from scratch. The wooden house is constructed around existing trees using natural, renewable and locally sourced materials.

LYNN MYLOU 'Routine is something I'm not very good at. I've always been very intuitively guided'

got done in time, and everyone was still happy. And I actually had more money at the end of the month than when I was working like crazy.

Back then I spent a lot of time in nature and had moved towards other interests, so I sold my apartment in Amsterdam, bought a van, and was able to leave.

Did you have an idea of where you wanted to go? I knew very strongly that it had to be Portugal even though I had never been here before. I was drawn to a certain area on the map not knowing why. I went to see a real estate agent that was recommended to me, and she gave me the GPS coordinates of this place.

When I saw it, I knew it had everything I was looking for; it was a really strong intuitive feeling. The whole trip was about that, not having any plans and just allowing myself to be guided to places. It was only once I'd bought the land that I found out about the eco-minded community here and all the areas of beautiful nature. It started to make sense why I had to be here.

Can you explain what your project is about? The idea is to establish a test and demonstration ground for the topics of food, shelter and wellbeing within a circular economy. I want to show that you can live a modern, comfortable life in a carbon positive, non-toxic place. I want to experiment with foods like forgotten fruit and wild, edible plants that are very abundant here. At the same time I want to invite people to experience this place or to join a workshop. So it's also about education and inspiration.

After learning about 'cradle to cradle design' as described by William McDonald I realised this is the umbrella I want to work under. It's one of the first design practices that captures the whole picture and doesn't just look at one part of the chain. It takes nature as an example and I think that's where we have to go back to, because nature has a flawless design.

How do you fund your work? I had a bit of money from selling the house. I was able to buy the land and build the birdhouse. I did a crowdfunding campaign in January, and the workshops bring a bit of income. I'm now thinking about providing an online platform where I can share things I have learned, like a

paid membership. The idea is to have regular live calls where people can ask questions.

In the future the plan is to make money with a bigger project that involves education, tourism and products. I'm currently working on a business plan to get investors. To me, sustainable projects only work if they are ecologically, socially and financially sustainable.

Where do you get all your knowledge from? Mainly from the Internet and books – I'm a researcher so that's my thing. I'm not someone who joins a course or a class. I study on my own and make my own conclusions. Of course I also need a lot of expert knowledge, so I talk to a lot of people.

What has been the biggest challenge so far? The biggest challenge is dealing with the corporate world, but I don't have much to do with it anymore.

I don't really experience hardship, because it all depends on your own perspective. There are challenges, but I find them all very beautiful. I don't experience them as I used to in the city, because of my own personal transformation. Whenever I feel resistance or unpleasant emotions, I'm now very well equipped to sail through those with ease.

This year I had a bit of a cash flow gap. I had to get over my own fear to ask for help in my network. I postponed it because I felt embarrassed. But then I did, it happened, and we could move on.

What does a typical day look like for you, if there is one? I approach every day with 'what do I want to do today' instead of 'what do I have to do'. Sometimes it's also about what the elements want from you. It can be very hot or raining, so you work with that. I take every day as it comes rather than having a strict calendar or following a to-do list.

LEFT Lynn's home is off the grid and self-sufficient — complete with its own electricity, heat and water supplies. Her land covers an area of 2 hectares and includes several self-built structures to host friends or guests staying for the workshops she holds regularly — a way to experience what Lynn calls 'luxury life activities' such as forest bathing, wild foraging hikes and outdoor showering.

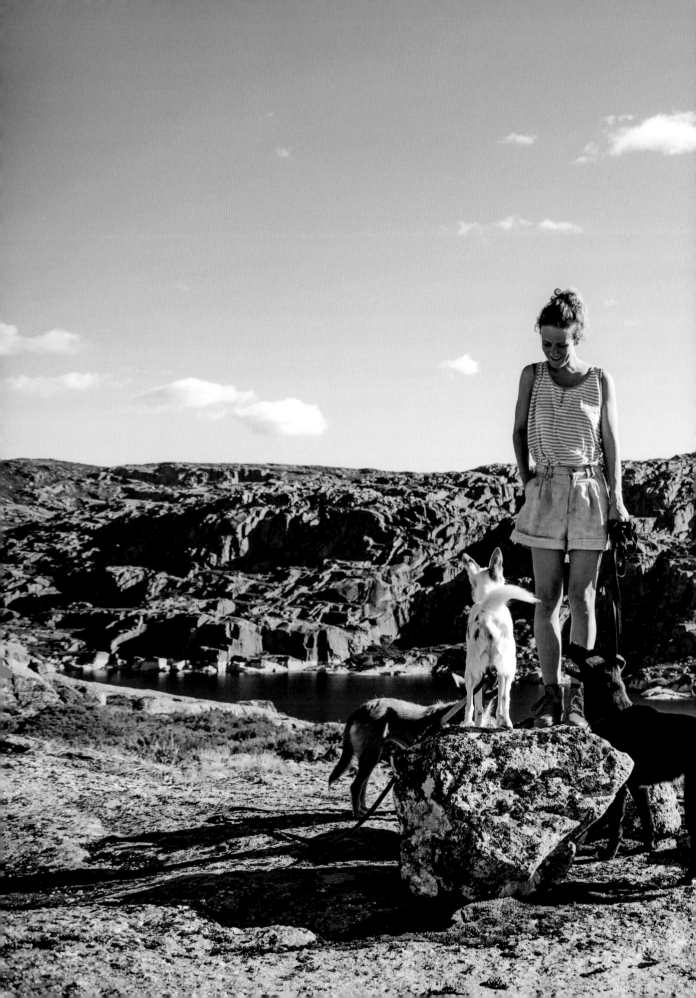

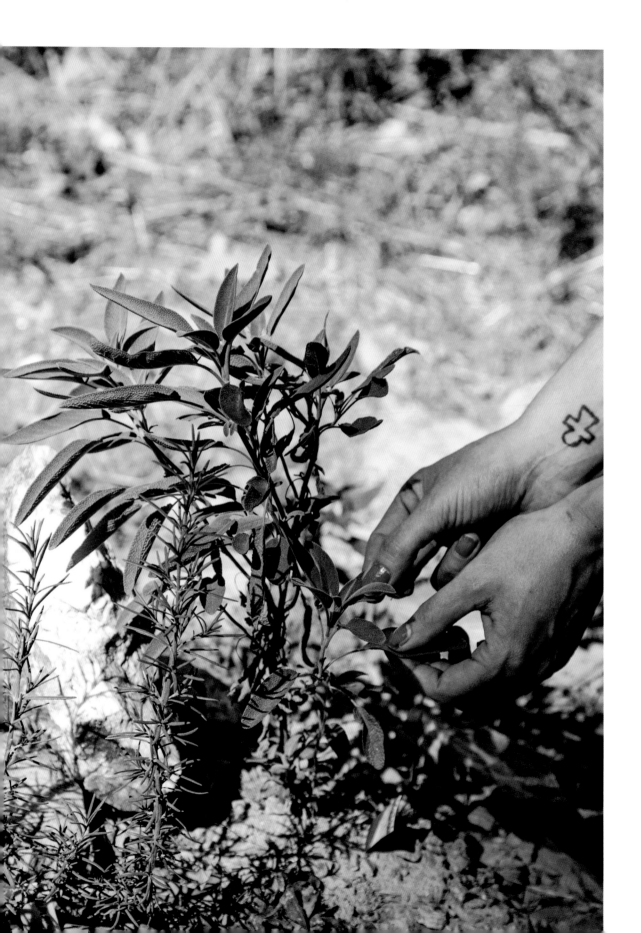

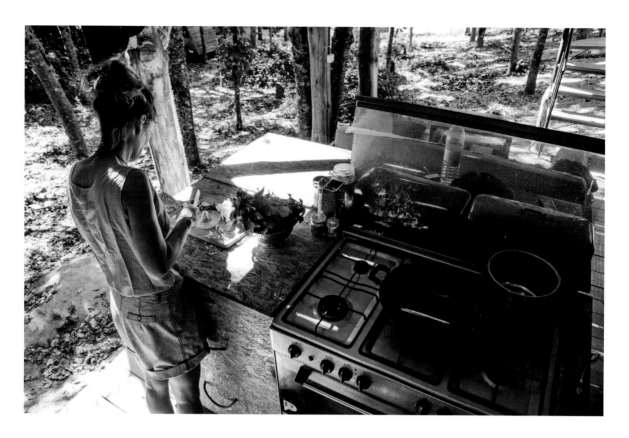

Since living here I am also much more in tune with nature. The moon cycles have become very important as well as my own. Energetically speaking there are times for doing, and there are times for being, times for the outer, and times for the inner. That kind of energy really determines whether I'm active on the land, working on the computer, or spending more time with myself, making plans or those kinds of things.

How did you get into this more intuitive routine? When I left Amsterdam I started to learn more about energy — I was very spiritually suppressed by my upbringing, my environment, my work, and all of that. Back then I had a

PREVIOUS SPREAD After purchasing her land, Lynn discovered the natural beauty and diversity she is surrounded by — from ancient forests and mountains to natural pools, lakes and waterfalls.

TOP Lynn has a keen interest in wild edible plants and their medicinal properties — something she wants to continue to learn more about. Her large, open kitchen is the perfect place to enjoy and experiment with those ingredients.

very spontaneous Kundalini awakening without having ever practiced yoga or meditation before. I thought you had to be a monk in Tibet for 10 years to experience this. It set a lot of things in motion. I started to learn about the universal language of energy and the signs behind it. My understanding of these ideas really improved through practice and observation. It would have been impossible to learn in the city where you are so detached from nature.

Do you follow a certain practice? No, not really. With everything in my life, I can't really follow teachers [laughs]. I freewheel everything. I meditate when I feel like it. Sometimes I do full moon or new moon rituals, sometimes not. Routine is something I'm not very good at. I've always been very intuitively guided.

How have the locals reacted to what you're doing? They're very friendly and they have helped me a lot, especially in the beginning. They love the fact that somebody inhabits this area again after 20 years of it being abandoned. I'm bringing in young people who spend a little

bit of money at the bar and the cafe. They really like seeing young people coming back to the land that's so precious to them.

What's your approach to social media? I use it a lot. Through social media you can show the entire world what you're doing and why. It's one of my jobs or callings to inspire as many people as possible to make conscious decisions in their life. I don't expect them to move to a place like this, but I strongly believe that inspiring others – however big or small the seed is that I can plant – helps to transition towards a more sustainable life for all of us.

Do you ever feel overwhelmed by the online world? No. I can choose to be online a lot, but I can also choose to unplug. For the entire month of August I completely disconnected. We think we have to be available 24/7 to everyone but it's bollocks. Even in the city you have that choice.

Whenever someone is truly present and you experience something together, like a walk or a swim, it is the best feeling in the world. You have to be conscious of yourself first in order to be present with someone else – it takes practice. In a city there are so many distractions making it really difficult. Whenever you sit somewhere in silence for a minute people find it awkward. You can see how brainwashed we are.

You mention luxury on your website. Can you describe what luxury means to you? True luxury is a feeling inside you that comes with freedom, independence and a deep sense of inner peace.

Not being controlled by any contracts or big corporations that don't act in your best interest. It also means detaching yourself from societal expectations. We're so bombarded with that and it puts so much pressure on us.

I don't have much of monetary value here, but I feel so rich because I am in a beautiful environment. I can sit somewhere and be totally happy with how the sun shines or how the butterfly moves.

Is there anything you miss about city life? Not really. Maybe international takeaway food. After a long day of work you just want to be lazy and have the convenience of that sometimes.

How much time do you spend on your own? I love being on my own. Time seems kind of non-existent here – weeks can go by and it feels like a day. I took some time off in August and I think I spent 3 weeks on my own, but I can't really say for sure.

One of the things I learned is that my biggest responsibility is to be the best version of myself. If I take really good care of myself, the external world will reflect that positivity back to me, and everyone will benefit.

What are your plans for the future? I established this project for myself to connect more with nature and to learn and develop my own skills. I want to set an example for other young people to follow, doing it in their own way obviously.

The long-term vision is to create an eco-zone of approximately 3,000 hectares within the larger community. In the short term I want to establish a habitat for four permanent households on my land that all contribute to the project. By sharing resources we can live on a 4,000 m^2 footprint each and produce a surplus to feed about 20 people per day, every day, throughout the year.

For me, local self-reliance is one of the key aspects we have to achieve. In the beginning it may not be possible, but over 10 or 20 years I hope to come close to at least 80% local self-reliance. That's the big plan.

Note from author: A few weeks after I spoke to Lynn, her house and farm were hit by one of the most destructive wildfires in Portugal's history, and both burnt to the ground. She is working hard to rebuild her project, and regularly posts updates to her Facebook page.

→ FACEBOOK.COM/LOETJE.LOE
→ AVIDAFAUSTO.NET

RIGHT Lynn describes her animals as 'important teachers and companions'. Her project 'A Vida Fausto' is even named after one of her dogs, 'Fausto'.

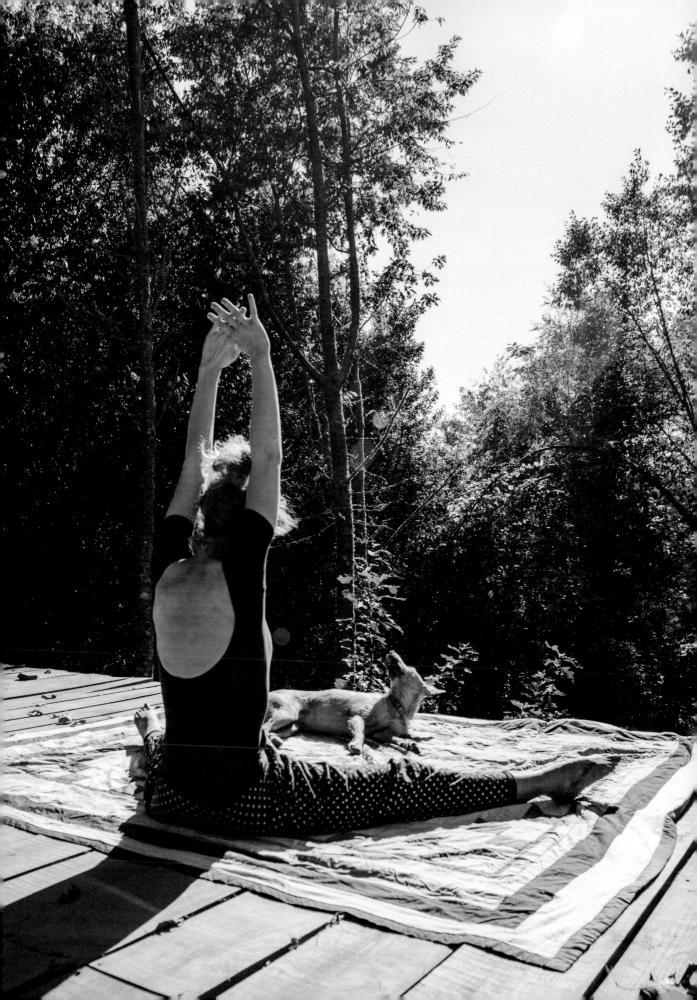

LUKE EVANS artist and photographer

'I've toyed around with pyrotechnics and explosives. I can just sneak around on the farm and blow things up'

Berlin → London → **Withington, Herefordshire, United Kingdom**
population 1,600

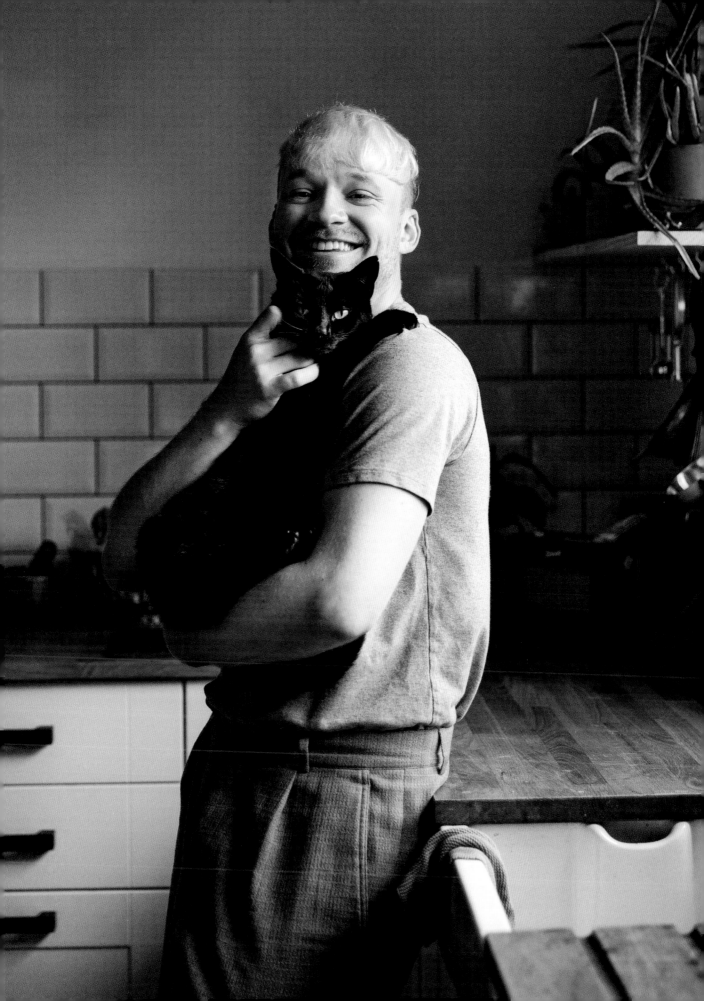

Straight after university, and with high critical acclaim for the work he was producing, LUKE left London for his hometown in rural Herefordshire. His drastic move proved to be a good one, both for his mental and physical health, and his creative output. In his studio on top of a hill he has the space to experiment, work on large-scale projects, and, occasionally, play around with pyrotechnics. While he still takes on commissions to keep afloat financially, Luke is enjoying the freedom that rural life provides, and the lower stress levels that come with it. Social isolation can be a struggle, he admits, but his work and feline companion keep him fulfilled.

What made you want to leave London? At the time it was very intuitive, but picking apart the idea, I feel like I didn't really have a choice. When I graduated my personal work was peaking so much that the idea of pushing it aside just wasn't an option. Charles Saatchi saw my photography in my second year of university, and I won a D&AD award in my third year.

I could stay in London, get a job, and do my personal work on the side, or pack London in entirely and concentrate on my own work where I could afford to. And there were so many other things that I wanted to explore and try out photographically.

There are people that have a long career in London before they have the stability to leave, whereas I did that at the beginning. I don't really think enough about how radical it is that I've managed to do that at such a young age.

What brought you to Herefordshire? I grew up here surrounded by hills and lots of space and I just felt like I needed that at the time. I live on top of a hill on a farm — there isn't another house around me for 20 minutes, it is so isolated. It allows a lot of time and space to reflect on your work. I don't know if I would be doing what I'm doing now if I'd stayed in London.

The disadvantage of being in the country is — although you have more time and you can get a lot more with your money — it can make you lazy. I wake up and the birds are singing and the cows are out. It can be really comfortable.

I think I recognised that about a year after moving back. I realised that the pressure I was under in London was one of the catalysts to make really good work. I had to make very quick decisions, I didn't have the time.

That's an interesting point. How do you manage that? It's hard, but I don't feel like this is going to be forever. It was needed at the time. I was super burned-out, producing work at such a quick pace, sleeping 3 or 4 hours a night. It just wasn't sustainable. I had to come back, chill out and reflect a little bit, and then see what happens. I will probably move back to the city at some point. It's this constant oscillating thing.

How did you find this place? Initially when I moved back I lived with my parents. I was working in their living room. I did so many shoots that you'd look at and think it was shot in a studio in London with a team. But it was just me in my parents' living room, with these terrible lights. It was really fun [laughs].

After 10 months I started looking for a studio space. You would think finding a space in the country would be easy, but there was literally nothing. Eventually I found this old barn that was full of old machinery. It was amazing. The actual state of it was awful, but the space and the size was great.

I was in the very fortunate position to have some money from the Saatchi Gallery. It's still very rudimentary — all we did was build a room inside of a room, with a poured concrete floor and hardly any insulation — but it's perfect. It's just what I needed. A bit later I moved in next door and now I can just walk to the studio.

How has the move to the countryside affected your social life? Socially it's difficult. It is so isolated here — the nearest cities are all miles away. All of my friends from here have

PREVIOUS SPREAD LEFT Luke's home and studio: a disused farm building that allows him to work on large scale productions.

PREVIOUS SPREAD RIGHT Woody the cat — Luke's companion.

RIGHT Luke's unique style of photography has earned him some notable attention, and a prestigious D&AD award.

gone. There's a gap in the population: you have the teenagers, then everyone my age disappears, and then you get all the retired people.

Also, being a gay guy in the middle of nowhere is like social suicide. I was in a relationship for about 8 years, but when I moved back here we broke up. It would be so nice to have someone, but the people I'm into live in London or the city. I want to be with someone who is doing amazing things, I want to be inspired by someone, and I'm not going to find that here; or at least I haven't, yet.

I go on Tinder – it's swipe, swipe, swipe, swipe, nothing. The guys are either 16 or 65. I think I've just come to terms with being happy being single, finally. I have my work and I have my cat [laughs].

I present myself as quite extroverted; if I give a talk or something I come across as this really outgoing person but, really, I am quite introverted. Some of my friends in London just couldn't imagine moving out to the country. They were terrified that they'd be stabbed or something, because it's the middle of nowhere and this is where all the murders happen, all Agatha Christie [laughs].

I grew up here, so moving out here had a sort of homeliness to it. I don't know how you could explain to someone who's lived in the city their whole life what it is actually like to live here. Until you've experienced a very limited social atmosphere, you just can't imagine what it's like.

Has moving here had an impact on your health? I probably would've been in a really bad situation if I'd stayed in London. Mentally I go through high and low periods. I feel like being in a city would've just amplified those quite a lot. It's interesting thinking about mental health with people of my generation. Living in the city you are faced with the problem of making money. If your talent is doing something creative, which traditionally doesn't pay much money, but you need it because that's what keeps you going, what do you do? For me, the only answer was here.

The countryside really is over-romanticised, but I love it. Being able to go on a walk and breathe fresh air is really, really nice, as wanky as that sounds. I think at this point in my life I'd rather have that and miss out on the social side of things than be really social and miss out on the lower levels of stress that I have here.

The other thing is that I was diagnosed with testicular cancer about 3 years ago. If that had happened in London, I don't even know if I would've survived being there.

My family all work at the local hospital so I had their support and excellent treatment. Having my family around at that time and not having to worry about money was a huge benefit. I feel like it almost confirmed, in a really horrible way, that moving back here was the right thing to do.

I can imagine. Are you now fully recovered? Yes – all good, which is great. I still have x-rays and blood checks, but I feel a lot stronger mentally. Maybe now I could handle the stress of living in the city.

Has your personal work changed since you moved? Is it influenced by your surroundings in any way? Creatively the freedom and the space that I have here really inform my personal work. I'm allowed to get away with stuff I wouldn't be able to do in London. A lot of my work does sort of teeter on legality.

At the minute I'm doing a project called 'Second Nature'. I am interested in how we imitate, mess, and play with nature, because it feels so sacred. I've worked with the idea before. In university I did a project called 'Forge', recreating natural landscapes in my kitchen, using paper and other day-to-day materials. I was

PREVIOUS SPREAD Luke's large studio is in an old barn conveniently located right next door.

LEFT Plants and books fill many of the available surfaces in his home.

LUKE EVANS 'Shooting bows and shooting cameras is very similar. You wait for everything to line up right. It's very meditative'

responding to the environment that I was in. I was in the city and I wanted to make these dreamy landscapes.

Now I'm able to scale-up the work. I've toyed around with pyrotechnics and explosives. I can just sneak around on the farm and blow things up [laughs]. I'm building these things and mixing it with studio work. Each picture takes a month.

Another project I'm working on is about cancer. I'm making artwork with chemotherapy drugs. I've attached a microscope to my large format film camera, so I'm really investigating the drugs and what they look like visually. As I'm going through this process of being observed all the time, I wanted to grab it by the horns and get all these drugs and really mess with them. It's about having control. This project has turned into a weird therapy.

How do you find clients for your commercial work? It has just been word-of-mouth. I have a good working relationship with some studios and once you've done a project they commission you for other jobs. I've also been speaking to an agent who's been really interested in my work. Their idea is to commission people for commercial jobs based on their personal work.

I'm interested in how you use social media. What's your approach? It's difficult because my work doesn't fit into the social media way of consuming content. It takes a little bit of time to understand it. You need to know how it's made. I actually really struggle with that, especially on Instagram where people just don't have any time, they just flick through. My work doesn't suit the platform very well.

I am getting better though. It's really interesting how Stories [a feature that lets users post content that vanishes after 24 hours] are now so integral to so many social media apps. My day-to-day is quite interesting and I've always wanted to share that, but not let that influence the cleanness of my feed. Now I can post in my Stories and be way less worried about how it's going to look, because it disappears after a day. I can keep the feed very, very clean.

Do you ever feel under pressure when you see what others are doing? Oh, yes,

totally. I used to feel that pressure a lot, especially when I was making work at such a rapid pace and every year something big was happening. Until I realised everyone's lying and nobody knows what they're doing.

Everyone's in the same boat, everyone's terrified, everyone is scared, and everyone feels like they're not being listened to [laughs].

I know you have also taken up archery. Can you tell me about that? I started archery when I was diagnosed with cancer, about 3 years ago, and I just fell in love with it. It's the most amazing thing, it's so therapeutic. Shooting bows and shooting cameras is very similar. You wait for everything to line up right. It's very meditative. It's a mental game more than a physical one.

It has slowly but surely taken over my life just as much as photography. I'm now on the Archery GB Development Team [Great Britain's Olympic development team], which means I need the space the countryside provides more than ever. Now I'm sort of tied into being here because I practice at the training centre every month for a few days. Luckily, being on a farm, I have the space to shoot at home.

What are your plans for the future? Make some badass work. This year is a big one for me: I have two new personal projects that will be coming out, I've got a show at the Saatchi Gallery later this year, I'm launching with the agency, and archery is taking off as well. A lot of work.

→ LUK-E.COM

PREVIOUS SPREAD Archery is an important part of Luke's life. He practices daily on the farm — thanks again to the open spaces — and has ambitions of competing as part of Britain's Olympic Archery team.

RIGHT Luke is currently working on a project titled 'Second Nature', exploring how we 'imitate, mess, and play' with nature.

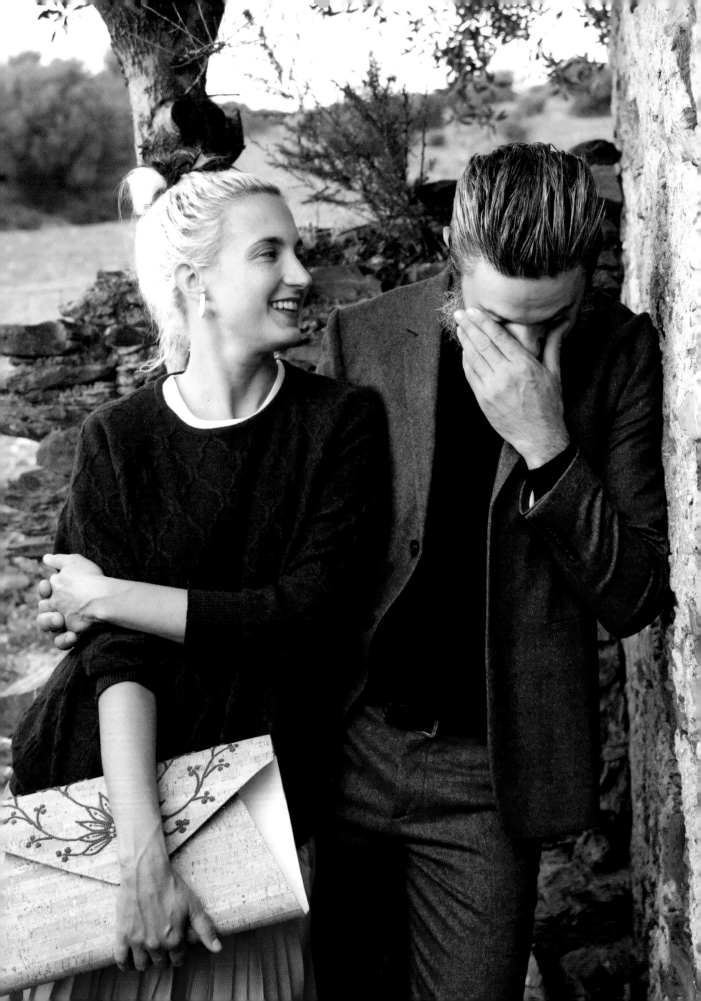

IVANO ATZORI & KYRE CHENVEN founders of Pretziada

'What's amazing about this day and age is being able to feel like you have access to all these different worlds even though you are based in the countryside. It protects you'

New York → Milan → **Is Aresus, Sardinia, Italy** population 6

It's hard to imagine a more metropolitan-minded couple. KYRE, originally from California, has worked in set design and creative direction in New York and Milan. While IVANO, a former graffiti artist who has collaborated with major international brands, once owned a clothing store in Italy's fashion capital. So when they abandoned their urban lives and moved to a tiny village in Sardinia, their friends thought they were crazy. Six years later, Kyre and Ivano sit at the helm of Pretziada ('precious' in Sardinian) — a successful creative project that explores the particularities of the island they call home, with the mission of showcasing the excellence of local artisans in an innovative, modern way.

What made you want to move away from the city? KYRE CHENVEN: Initially, it was very banal reasons such as more silence and a better quality of life as parents. But it was also the idea of a new start, and a slower rhythm that would give us time to reflect and think. We do love cities and all they can give, we just feel we get much more from them as visitors on vacation while living full-time in the country.

The interesting part was to develop a survival strategy. We've always lived in cities and worked in creative areas, so we knew we needed more from the countryside than just lavender plants and peace at night.

We had to find a way to blend country life with our metropolitan souls; a way to use all our skills, knowledge and interests and have them come together in one project. We realised that project was going to end up being our daily mission. We probably 'work' way more than we ever did in the city, but work is life and enjoyment now. That's how Pretziada started.

Can you describe what Pretziada is about? KC: We have one sentence on our business card that says: 'Pretziada is an interdisciplinary project combining the worlds of design, journalism, photography, craftsmanship and tourism.'

In Sardinia there's an incredible heritage of crafts that is not well known outside of the island. It was very home-based, with people making excellent products like tapestries, clothing and knives, all from their basements. You didn't buy things from other people; it was more about how good you could get at doing it yourself. There's a strong personal sense of excellence.

The first step was to introduce Sardinia to the world. We started a journal talking about all the things that are particular to the island. From the very beginning the idea was to work with artisans and have designers come here and create something that was based on Sardinian life.

How has the rural surrounding influenced your creativity? KC: I think you get to a certain age where you can find coolness in everything. Moving here was freeing because it

TOP The Pretziada Boot is a polished remake of the classic shepherd boot, once the only shoe worn in the south of the island. Women, men and children all had two pairs: one for the country and one for the town.

LEFT The family home — or 'Pretziada HQ' as Kyre and Ivano like to call it — is based in a remote location in the Sulcis region of Sardinia. The couple are currently in the process of restoring three other buildings on their land, so they can welcome visitors and designers they collaborate with.

removed all interference. You don't have to be constantly reminded of what everybody else is doing. You can give the right weight and time to certain projects and be influenced by your natural aesthetic and interests, and that's really refreshing. I don't know if we could have done this 10 years ago. The silence that you gain helps you find your voice in a lot of ways.

IVANO ATZORI: In cities you have to deal with constant distractions and expectations. Those are probably the biggest limitations for the creative process. Most young people here are desperate to leave – they need to escape, they need contamination, and they need to be surrounded by crazy noise. We'd had enough. I think our minds and bodies were not able to take any more.

How did you adapt to life in the countryside? KC: When we decided to move to the countryside almost everybody who knew us said, 'this is crazy, you guys are out of your minds, Ivano is never going to survive.' He was

such an urban person to people. Nobody could wrap their head around the fact that he might be able to live somewhere outside of the city. But one of the first things that we both realised was that when you have a difficult moment here you can just take a walk outside, or go to the beach for a swim. It may not get to the root of the problem, or change your existence, but it's amazing to see how much you can calm yourself when you're allowed to.

Frustration can disappear very quickly when you're surrounded by silence, and it's a total gift to have plants and animals around. I feel like when you're in the city you constantly have to be protecting yourself against your surroundings in a way that you may not even recognise.

I think whether you're happy living in the countryside has a lot to do with figuring out how you want to spend your free time. There are those who feel more comfortable spending their free time on a metro observing the people around them or distracting themselves. And then there are people who feel exhausted on that ride home because they feel they need some sort of physicality to their life that, in modern times, we just don't have any more.

What have been the biggest challenges? KC: Of course we have doubts sometimes. But being surrounded by magical nature, excellent food for a reasonable price, and a community always ready to support you, helps us remember that our society started from these small agricultural beginnings and now we understand why.

We wouldn't suggest it to everyone. There are simple comforts in the city that we take for granted that make life so much easier. Here, a blown fuse can take 3 days to fix: 15 phone calls, ten trial and errors, and four trips to the nearest city. And maybe that one blown fuse means you have no running water or some other

LEFT Working closely with local craftspeople lies at the heart of Pretziada's approach and philosophy. Here is a detail from Walter Usai's workshop, who's descended from generations of Sardinian potters.

RIGHT The Marria Vase, produced in collaboration with designer Valentina Cameranesi and Walter Usai, plays with the elements of the traditional nuptial vase gifted to young brides on the island.

IVANO ATZORI 'Cities are contemporary ghettos. I don't think you can grow as a human being if you're not talking to people that are different to you'

putting in the hours and getting quality work done. I could sit in front of the computer for 5 hours and end up with nothing at the end of the day. And it would have been much more productive for me to continue building the rock wall outside.

Do you give yourself permission to take these kinds of breaks from your work? KC: We're getting better at it.

IA: It's something that I do quite often. It gives me more satisfaction. Unfortunately, it's not really helping financially.

KC: But Ivano, I find you often come back inside from working on the rock wall for example with more ideas than if you had been sitting in front of the computer.

Does the weather affect you? KC: The weather is way more influential on how you spend your day and your year than it is in the city. The heat can be extreme. Sometimes we have large amounts of rain and things get flooded. In a way it's a more archaic way to live because you have to have a real connection with nature.

It's not idealised like, 'I'm going to plant lavender and then collect the flowers'. It's more like, 'there's a snowstorm and I can't get to town because no one dug out our road. I'm going to have to live in my house for the next week.'

IA: You need to accept it. If it's raining, you're going to arrive at your appointment wearing shoes covered in mud. If it's 45 °C outside, you need to rest otherwise you're going to get sick. You're not able to work because your brain doesn't work. It can be very frustrating feeling like you can't produce.

What's your approach to social media? IA: We don't have a personal account, but for Pretziada it is necessary to say we exist. We have even sold pieces by posting a nice

modern necessity. But if you are willing to trade that for the ability to really be alone with your own mind and the people you love, then this is a great life.

IA: Our rhythm is still the urban rhythm. I remember in the first 2 years I used to hate going to the greengrocer because I'd get trapped for an hour in a beautiful conversation about vegetables. I was like, 'I'm wasting my time here. I need to go back, I need to respond to emails.' I'm getting better though. You have to — otherwise you're going to hate it.

Have you become more accepting of the local pace? KC: Something that you learn very quickly when you are running your own business is that there's a difference between

PREVIOUS SPREAD Leroy, born in Brooklyn, and Antioca, born in Milan, playing on top of the salt dunes on the nearby island of Sant'Antioco.

TOP Antioca and Leroy paint graffiti inside one of the old buildings on their property that will soon be renovated.

RIGHT Urban meets rural: Ivano finds a new canvas for his graffiti writing skills.

KYRE CHENVEN **'Frustration can disappear very quickly when you're surrounded by silence'**

picture on Instagram. We are cut off from the world geographically so there is not a lot of contamination during our day-to-day life, but Instagram is like a window to the world.

KC: You can use it to make connections that you otherwise had to be travelling the world to make. Next week a ceramic artist from Brooklyn is coming to our area. It's sort of a coincidence, but she followed us on Instagram, and we're going to have dinner together. It's fascinating when you can have real high quality connections through something that seems so superficial.

How easy did you find it to connect with the local community here? IA: Well, we moved to a community that, for the last 2,000 years, probably hasn't changed that much. We are outsiders for sure. Aliens, compared to the locals [laughs].

You need to have a constant appreciation for everything they do. That's the easiest way to be included.

KC: It's not hard to be amazed by the incredible olive oil that your friends make when you've never done it. I think the main thing is realising what everybody can add to your life. Being able to remember the humanity in everybody is one of the huge things that helps keep me focused on what we're doing.

Our situation is very particular because Ivano speaks Sardinian. Even though everyone here speaks Italian, the fact that he spoke Sardinian and was from a nearby town made it a lot easier.

Another big advantage is that we have children. That gives you access to people. We have made some really good contacts and connections with people, and sometimes we feel closer to them than some of our longer-standing friends in cities.

Do you ever feel people are less open-minded than in the city? IA: Sardinian people are particularly curious. When they see something moving differently, or being coloured differently, or acting differently, they just find a way to get close to it.

Cities are contemporary ghettos. I don't think you can grow as a human being if you're not talking to people that are different to you.

In the city it's really difficult to have that opportunity because you just surround yourself with people exactly like you.

KC: The biggest surprise to us was when friends would come to visit and say, 'don't you get bored?' When we'd go back to visit them in the city we realised that they were all going to exactly the same shows, talking and working with the same people and, in a way, moving in much smaller and less varied circles of people than we interacted with here. It was a real wake-up call.

It's fantastic to feel like you're talking about broader things, that you're talking about life in general. I think more than anything you start to make connections between things that otherwise can be difficult.

How often do you visit cities? KC: Not as often as we should or we'd like to, probably. Maybe three or four times a year. If I only lived here it would feel stifling. What's amazing about this day and age is being able to feel like you have access to all these different worlds even though you are based in the countryside. It protects you.

IA: Of course I do miss the city sometimes, but I also need to remind myself that it is always there for us. It's very easy to get in touch with the city environment or atmosphere. But it's not that easy to live in the city and be close to the countryside and the opportunities it brings.

→ PRETZIADA.COM

PREVIOUS SPREAD TOP RIGHT The Allusion Carpet, another Pretziada project, is based on traditional Sardinian bed covers. Always monochromatic, these textiles were covered with a raised 'pibiones' pattern depicting various plants and animals. This rug is hand-woven, and made from undyed Sardinian wool.

PREVIOUS SPREAD BOTTOM RIGHT Kyre taking care of Leroy's knee.

RIGHT A goat stuck in the shed, trying to reach food left by the shepherd.

PAUL WEBB beekeeper, co-founder of Black Bee Honey

'People are very supportive of new stuff happening. It feels like there is a much more appreciative community for starting new things'

London → Manchester → **Pitcombe, Somerset, United Kingdom**
population 500

PAUL *was running a design agency in London when, after attending a course in the city, he picked up beekeeping as a hobby. What started as a side project quickly turned into a successful company — selling locally produced urban honey to luxury department stores like Harrods and Selfridges. He and his co-founder soon shut down their respective agencies to focus on honey full-time. Searching for a greater quality of life took Paul to rural Somerset, where he found an increased connection to nature and a happier environment for his family. But more surprisingly for him, it was the encouraging community of entrepreneurs, and ideal location to grow his business, that provided the biggest contrast to his life in the city.*

What made you want to move to the countryside? Initially our move to the countryside was purely to improve our quality of life and find somewhere where we could live and start a family.

Why Somerset? We had some good friends here that we have known for a long time. And in terms of food businesses it's a really interesting area. Some great companies are based here like 'Westcombe Dairy' and 'Wild Beer'. In Frome there is an independent market and lots of small, interesting businesses. It really appealed to us from that point of view.

Kate [Paul's wife] has an interior and design store in London called Nook. She could see the potential for setting something up around here as well.

What have you been up to since you moved here? Two weeks after moving our son Billy was born, so Kate focused on him. The house we moved into needed a lot of work, and we've been spending a lot of time doing that. Then we got married, and I launched the new company, Black Bee Honey, in September.

The whole year has been about change — the baby, the move, marriage and the business.

But we don't regret the move in the slightest. I think it's one of the best decisions we've made.

My new base is a co-working space in Frome with lots of other small businesses. In the future I'd like Black Bee Honey to be based either in Frome or Bristol. They are both really interesting places for food.

How did you get into beekeeping?
Me and a friend went on a beekeeping course in London. We really loved it and went on a few more courses together. Chris ended up travelling to New Zealand and worked on a bee farm where they were doing hive rental. When he came back he said we should do the same thing in London and it started from there.

It was quite daunting at first, but we learned quickly. By the second year I was doing independent inspections on hives.

I'd been in design for about 15 years and I never really got much satisfaction out of it. Me and my mates would always be planning hikes in the Himalayas and walks in the Lake District, spending as much time in nature as possible.

LEFT & PREVIOUS SPREAD RIGHT Paul inspecting some of the beehives he has installed near his home. His aim is to 'change people's perceptions of what honey is... [and] show the magical journey — from flower to hive to jar.'

Beekeeping kind of enabled that connection to nature in the city, but moving out here means I get to be even more connected.

What's your vision for Black Bee Honey? We are trying to change people's perceptions of what honey is. We want to show the magical journey – from flower to hive to jar. We are working with British bee farmers, it's a profession under threat. They are on the decline as much as the honeybee is. We want to support the farmers, and build an exciting brand.

There aren't any honey brands that people relate to – they are all very generic. We want to offer people something different and show the variety of honeys and flavours from all over Britain.

Are you going to produce the honey for Black Bee Honey yourself? We still have bees in London, and I have installed a couple of hives here for the next season, but on a smaller scale. It keeps us involved and enables us to take people to hives and show them what an incredible product honey is.

Beekeeping is very time intensive and risky as a way of generating income. You're so dependent on the weather and on how the bees perform in the face of diseases and pests.

We're trying to build the brand, so we need the time to focus on that side of the business. We are working with a guy in Exmoor in west Somerset who produces a heather honey and a wild flower honey for us. He's been bee farming for about 30 years, has up to 1,000 hives, and looks like a wizard [laughs]. We've got quite a bit of experience, but it's nice to work with people who know the trade inside out.

How have you settled into the local community? People are very supportive of new stuff happening. They're very hungry for it. It improves their quality of life by offering

RIGHT When renovating the house, Paul discovered a hive of black bees — the original British honey bee which almost died out a century ago. It's a fitting emblem for his desire to support British bees and their keepers.

something new. In London people are very cynical about new companies. It feels like here there is a much more appreciative community for starting new things.

For example, there's a guy who runs a company called Artisan Food Club that works with small food producers. He has just moved here from London and sits two desks away from me in Frome. We're working with him to get our honey into Wholefoods. There's a girl that lives in Frome who has got a background in branding and has worked in food for years. She's been on maternity leave and has been working with us on the branding for Black Bee Honey. Then we work with various local advisors who are helping us with growing the business. They have a lot of expertise in the world of food businesses.

I made more connections here than I have since we started the honey company in London 5 years ago. It's just the way that people are talking about new things. It's something exciting and celebrated rather than berated and criticised.

The area has been undergoing quite a change, with lots of people moving here from London. Did you feel welcomed by the locals? This village was almost completely derelict in the 1960s. I think people who have grown up in Frome and Bruton are actually really positive about other people coming in and bringing creativity, energy and new ideas. Frome was also really run down 10 years ago. There wasn't much opportunity or employment and now there's a real energy about the place. People who have lived through hard times can see the benefits of people moving into the area.

Obviously if a place starts to thrive and gets more popular, it gets more expensive. There are positives and negatives to that kind of development. But the local community is very friendly. We took part in the local river clearance recently with the other residents of Pitcombe. It was a lovely event to get to know people better.

How have you adjusted in terms of your personal life? Kate is collecting friends at the moment. She is hanging out with a new friend every day. I'm quite jealous; I'm lagging behind on the new friend tally [laughs].

People are a lot more open to hang out with people that they have just met compared to London. We made a lot more friends here over the last 6 months then we had done in London for years. That's partly down to me being a bit blinkered and just hanging out in my set group of friends that I have established over the years – when we moved here we were forced to make a bit more of an effort. It's really good to meet people with different perspectives.

Having a baby also opens you up to a lot of people. I've never had so much attention since I had a baby [laughs].

Do you think the rural context has influenced your creativity? When I was growing up in rural Essex I was craving the city. The graphic design work I did back then was a way

PAUL WEBB 'I found the quietness quite challenging at first. It makes you reflect more and makes you more aware of your feelings. It's not always easy, but it's a healthy thing to be doing'

to create what I was missing, a way of creating an aesthetic that I didn't have in my life. And I guess here it's the same. We're surrounded by trees, cows, tractors and old buildings. And yeah, that's lovely, but in a way you want something that is a contrast to that experience. From a creative point of view it's quite satisfying to do things that are in contrast to the very traditional environment. If you make a statement it really stands out, whereas in London you're just adding to the noise.

Do you think having lived in a city gives you an advantage? In London I lived in Peckham and Stoke Newington. There you are exposed to so many different cultures – Afro-Caribbean, Pakistani, Turkish, Jewish. Out here there is nothing like that. It's quite scarily white and traditional, which isn't necessarily a negative thing. But having a broader understanding through my experience in London is definitely beneficial.

It's nice to go back to London. Being based outside of it makes me more receptive and appreciative of those elements of the city.

What have you found most challenging about living in a rural environment? I think being out here affects you psychologically. I found the quietness quite challenging at first. It makes you reflect more and makes you more aware of your feelings. It's not always easy, but it's a healthy thing to be doing. It affects your outlook and the way you're interacting with other people. You've got a broader mindset when you're in this environment.

You also need a different sort of skill set. Like stopping logs from getting wet and mouldy, or how to maintain a fence and stop cows coming in and trampling all over your fire pit, which happened recently [laughs]. Country skills. I really enjoy it, but you do feel like an idiot sometimes.

Do you make much use of the countryside that you are surrounded by? We try to go out for early morning walks. We get really nice misty mornings with amazing light.

I'm getting more involved with nature again, understanding it more. I remember growing up very immersed in the local fields, nature

and wildlife. I am rediscovering that again. And being able to give Billy the experience of growing up here is really nice.

And we've gone mental for foraging. Whenever we're out walking we're constantly scanning the floor for mushrooms or anything that we can potentially eat. It is an amazing area for that. A lot of the guys I know around here have been out looking for magic mushrooms because it's that time of the year. Some people seem to be constantly high on magic mushrooms [laughs].

What are your plans for the future? My plan for the future is to become more embedded in the rural landscape through work and how we live as a whole. We've only been here a year, so it still feels like a transition from one life to another. I've already seen the positive effect being here has had on all of us, but you still have to make a conscious effort to make a meaningful connection with the world around you.

→ BLACKBEEHONEY.CO

PREVIOUS SPREAD LEFT Paul's wife Kate still works at her London store 2 days a week, but is already thinking about her next venture. One of the reasons the couple settled in Somerset was its potential as a location for a new project.

RIGHT Paul had to learn some new 'country skills' after his move from the city – like how to maintain a fence and stop cows coming into your back yard, or stopping logs from getting wet and mouldy.

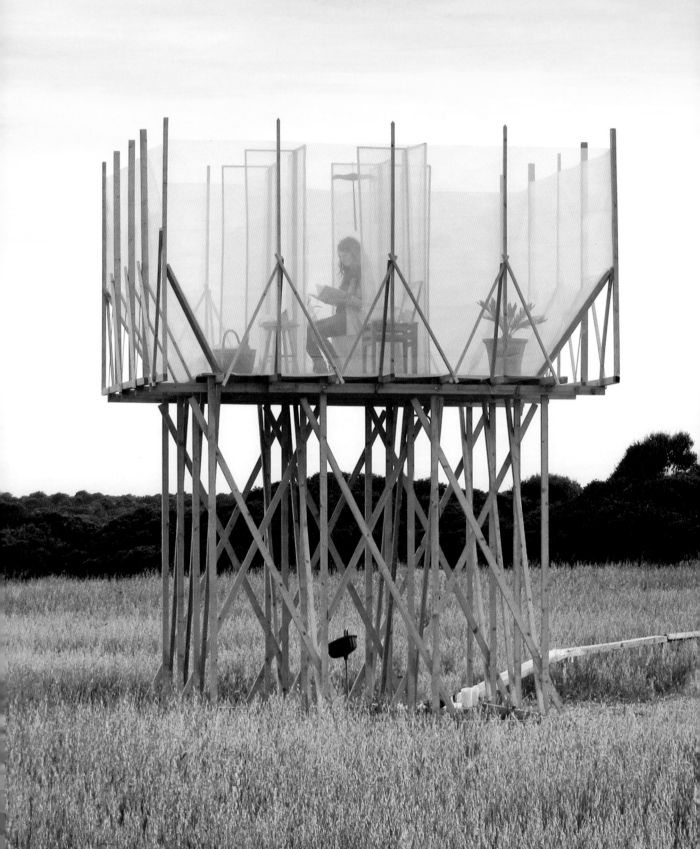

MARIANA DE DELÁS architect

'For our generation, being nomadic is everything. You have a bag here, you have a bag there, and you keep on moving'

Barcelona → Melbourne → Mumbai → Madrid
→ **Es Llombards, Majorca, Spain** population 500

MARIANA *epitomises a generation content with being on the move, comfortably switching from one environment to the next. The young architect divides her time between Barcelona, Madrid, and a remote agricultural estate in southern Majorca, owned by her family. Not quite ready to completely cut her ties with urban centres, Mariana is slowly realising a plan with her brother to renew the decaying stone houses and stable structures of the old family farm. Music festivals, architectural workshops and luxury off-grid accommodation all feature in this ancient agricultural land's future, as well as a distant hope to establish a more permanent base for her work.*

When did you set up your architecture practice? I started to work independently after being offered to design a hotel in Madrid. At that time a good friend of mine had just come back from New York, so we decided to join forces. Our clients are based in Barcelona, Madrid and Majorca. We don't have as many

clients as I would like in Majorca yet, but enough to start working in this triangle. The long-term plan is to set up my architecture base here.

What made you want to come back here? I want to revitalise the family farm. We have this family treasure and there is no ambition for change, everybody just keeps it as it is. There are a lot of cousins and uncles involved, but we have the opportunity to transform and renew it.

PREVIOUS SPREAD A light timber structure was the outcome of an architecture workshop hosted by Mariana. This so-called 'Grooming Retreat' — inspired by the ritual of cleaning a horse and it's meditative qualities — provides an elevated sanctuary. It's a place to rest, reflect and recover from urban stresses.

RIGHT The family farm extends over a vast area of land along several kilometres of rugged coastline. The buildings are grand, with most in need of renovation, adding a particular sense of urgency to Mariana's mission.

What is your ambition for this place?
The overall goal is to keep the estate in the family. I want to make the farm as splendorous as it deserves to be by exploring different ways to sustain it. There are not many places like this that have not been corrupted by money. But in order to make it economically sustainable the farm has to generate more income.

We want to fix old structures while creating interesting side projects. We have hosted two international architecture workshops where we created experimental structures using traditional building techniques.

In October we are going to host the first edition of a new music festival featuring experimental bands from Majorca. We restored the roof of one of the old buildings, which became the first wooden roof in the area. By fixing these buildings we also hope to create places for music residencies. It's so calm here, I think it would work really well for musicians.

We are also in investment talks to refurbish one of the main houses in order to rent it out. It will be an off-grid house, a very unique space that will self-produce all the energy it needs. It's a contemporary idea of luxury, offering privacy and connection to nature.

Can you tell me about the architectural workshops? The brief is always to build something in a short period of time with local materials and techniques. In 2014 we created a retreat for grooming and contemplation. It was a raised wooden platform in the middle of a barley field, a space that encourages you to take a break and reconnect with yourself. The idea was to focus on the ritual of self-cleansing, both mental and corporal. It takes inspiration from the philosophy of horse grooming which is the first thing they teach you when you learn to ride a horse.

PREVIOUS SPREAD Another structure built at a more recent workshop, with architects from Norway, India, Canada and Spain. The 'Well Tower' provides refreshment and shade for the local hunters and their Ibizan hounds, which are native to the Balearic Islands.

TOP RIGHT Mariana's simple studio setup. With the internet coverage being patchy, she's often forced to walk around with her laptop to send emails.

BOTTOM RIGHT A four-wheel drive is needed to get to the more remote corners of the estate.

Last year we built a tower for a well. The idea was to celebrate water, because it is so precious on the island. We promote the sustainable hunting of rabbits and partridges by means of Ibizan hounds that are native to the Balearic Islands, so we created the tower to provide water for the dogs and shade for the hunters. It offers rest and contemplation, but also functions as a place for social gathering.

How did people react to it? People use it more than we thought. It's funny when you create a landmark and people use it, just out of curiosity – that was one of the biggest things we learnt.

My aunt would never go for a walk before, but the grooming retreat became a destination for her. It was the same story with the tower. The hunters used to bring their cans with water, but now they use the well. They send me pictures, saying everything is still standing. The initial concept was more about the construction technique. Now, it has a life of its own which is really nice.

Do you think being here influences your creativity in a different way? Everything is done without planning here. People on the farm are very practical and I find that very inspiring. In my field we are obsessed with research and planning, but sometimes things that are done spontaneously end up being much more interesting.

What are the biggest challenges you have faced in the countryside? The hours you spend dealing with bureaucracy can be challenging. People on the island are very slow. Everything has to be done according to their pace. You cannot go to a town hall and have a whole project signed off like you would in Madrid or Barcelona. It's more about the relationship you create with the public worker than about the project itself. If you are not surrounded by people who are willing to help you, you won't get anywhere.

Everything is done by goodwill – we don't pay for things, we exchange things. If somebody wants to hunt on the estate, in return he will lend us a truck. Social skills are important, you can't become a hermit.

MARIANA DE DELÁS 'You need to have a plan and make yourself do it. Otherwise you're not giving anything back to the countryside and just become a parasite'

Also, it is very easy to be here and not do anything. You need to have a plan for what you want to create and make yourself do it. Otherwise you're not giving anything back to the countryside and just become a parasite — a city person who comes to the countryside to be calm.

Could you imagine living here permanently? Maybe for two thirds of my time. I think I will always have a foot in the city. I enjoy it. If you stay here for 1 month you end up adopting the rhythm of the locals and become lazy. When I go back to the city for a few days and then come back here it's amazing. I do everything much faster. It gives me a bit of adrenaline. My brother and I are getting so used to this rhythm. As soon as we are in one place for more than 2 weeks, we become restless. I wouldn't change it. It works for me.

Some of my friends from Palma are actually starting to live in the countryside as well now. Palma has become very expensive because of Airbnb, there's more demand than supply. So a lot of young people who lived in cities all their lives are moving to small towns because they can have a better lifestyle there.

Why do you think the countryside is becoming more appealing for young people? I think it's a combination of things. For our generation, being nomadic is everything. My mom always laughs about us getting all these airplanes, always being on the move. But it makes it a lot easier to live in the countryside. It feels like you're just moving through without having to fully commit to it. You have a bag here, you have a bag there, and you keep on moving. You don't have the feeling that you're saying goodbye to the city.

When my group of friends finished university in 2011, Spain was hit by the big recession. Everybody had to move, there was no other option. People moved to India, Japan, South America and so on. We got used to the idea of moving for work. When we started our own offices we didn't wait for people to hire us. We keep on following the projects we are working on, and the projects we want to work on. I want to have projects here, so I come here to find clients.

Do you think having lived and worked in major cities means you can bring something new to the countryside? I think everything we bring here is new. For example the combination of disciplines, like art and architecture. Or the idea of aesthetics and repairing things in a nice way. People here tend to fix things with whatever they have to hand. They are purely focused on practicality.

It's funny because people visit the countryside with this romantic notion about it, but for people who live here there is nothing exotic about it. It's all very practical. Everything you do that has no immediate or obvious use — something that is just beautiful or has a more ephemeral use — those things are really mind-blowing for the locals. Now they appreciate it, but in the beginning nobody understood what we were doing. I really enjoy challenging those perceptions.

→ MARIANADELAS.COM

PREVIOUS SPREAD RIGHT A refreshing dip in the water is never far away. Mariana closed off a small area of the reservoir to use as a pool.

RIGHT Mariana has found a balance, splitting her time between the city and her rural home.

RAINER ROSEGGER sociologist and cultural advisor

'At some point I thought we could introduce rules, but it will be far more interesting to use an anarchic approach. I see it as a bit of a research project'

Graz → **Wildon, Styria, Austria** population 5,300

At the edge of a forest in the small Austrian village of Wildon, a disused castle has been given a new lease of life by **RAINER** *and a group of like-minded individuals. An ongoing social experiment into communal living, Rainer, together with his collaborators, is exploring the benefits of more space, more opportunities, and fewer rules in a true fairy-tale setting.*

You are the first person I've met who lives in a renaissance castle. How did you find this place? Total coincidence. Mario, a friend and colleague of mine, was looking for somewhere to build a tree house and randomly discovered this place, completely empty. The owner agreed on a deal for intermediate use for 3 years. We cover the operational costs and look after the green space, and in exchange, we don't pay any rent.

You grew up in a rural area. Did you always feel an urge to move back to the countryside? Not really. Mario and I were really active in Graz. We initiated a lot of events and festivals, 'Lendwirbel', for example — a yearly festival that celebrates the local borough.

We always tried to find new ways to develop disused space. But at some point we felt we had exhausted the possibilities in Graz. This place here offered a whole new range of opportunities. That was actually what sparked my interest, the space to develop new ideas.

As a sociologist you are involved in a lot of urban developments. Did moving to the countryside make you shift your professional focus as well? Not consciously, but that's what happened. At the moment we are working a lot with participation processes, getting local communities involved. For example, in Bruck we're

PREVIOUS SPREAD RIGHT Schloss Schwarzenegg, now the home and work space for a group of alternatively minded individuals, was originally built towards the end of the 16th century.

TOP The castle used to stand empty. Now, upwards of fifteen people live here communally, covering operational costs and tending to the green space in exchange for free rent.

RIGHT With plentiful space, including a disused riding arena, there are no boundaries for residents and artists to experiment and produce large scale work.

doing a project called 'Habitat Mur'. The idea is to better integrate the river into urban life.

Our goal is always to develop something tangible for the local community, to build something that actually makes a difference as opposed to this kind of abstract 'flip chart thinking'.

How involved are you in the local community? Quite a lot actually. Mario is from here. Back in 2005 he organised a ball in Wildon Castle, and it was a really successful event. It was fascinating to see a mix of different scenes – punks from Graz were mingling with firemen from Wildon. It was great.

When the council heard that Mario was moving back here, they asked us for a meeting. They commissioned us to do a project to develop some vacant spaces in the village. There are a lot of abandoned buildings in the old historic centre, which is a very common problem in this area of Austria. Whereas on the outskirts you have all these detached family houses popping up.

Do the locals ever come to visit you here? Sometimes. There is one guy who is 100 years old that has known this place since his childhood. He always walks in and tells stories about how it used to be. A lot of people pass by when they go for a walk, but they keep their distance. They probably think we're a bunch of hippies [laughs].

How does your daily routine here differ to your life in Graz? It's a lot more relaxed. I try to arrange my appointments in a way that means I have at least 2 days a week to just work here. I don't spend any time commuting. I use this extra time to go for walks in the forest, or just spend some time outdoors to smell the roses [laughs]. It sounds like a total cliché, but it's true.

Seeing plants blossom and witnessing the natural cycle and seasons is a very grounding experience. In the city you don't really notice. We have a proper winter here as well, snow and everything. It feels a bit more real. You realise that you are part of nature, which has been a bit of a revelation.

This place is pretty unique. Can you describe your living arrangements? The whole living area covers 1,800 m². On top of that there are the arcades that we use a lot in summer.

Downstairs there is the chapel, the rose garden, garden shed, workshops, and the pool, although we stopped using it because maintaining it is a lot of work. About 5 minutes from here

What have you learned so far? The most important thing is communication. We make sure we hold regular resident meetings, and I think having a fixed number of hours per month that residents have to spend doing communal tasks would be a good thing.

Do you get a lot of requests from people wanting to live or work here? Yes, we constantly get inquiries. People wanting to spend a month writing here, for example. We decide on each case individually. Would they be a good fit? Would it add to our community? Or would it create more work? We always have some artists living here temporarily and that's usually been quite enriching.

Do you miss city life? No. The compelling thing about the way we live here is that there's something very urban about it as well. You've got your retreat, but if you want to socialise there are always like-minded people around. You just have to go up or down a floor and you can have a coffee or a glass of wine with somebody. You still have this exchange of ideas. If you move to the country as a family and live in a detached house somewhere it's a very different story.

you can swim in a river. I've never been to the Amazon, but it really feels like a jungle. Lush, green and totally overgrown. That kind of makes more sense than trying to keep the pool clean with a lot of chlorine. We did have a lot of fun with it in the first summer though.

How many people live here? About 15 of us, children included. Some live here permanently, others still have a flat in Graz. We all have separate bed and living rooms. There are a lot of bathrooms, some of which are shared.

We have one shared kitchen that gets a bit crowded sometimes, especially in winter. In summer we cook a lot outside. We've got a pizza oven and we do a lot of barbecues.

Are there any rules that residents have to follow? No, although that can be problematic. If you don't have rules it is always the same people who end up doing the chores. I'm involved in a lot of communal living and cooperative housing projects in Vienna and Berlin. It's a big subject currently. You quickly realise if you want to approach it properly, you do need rules.

At some point I thought we could introduce rules, but as it's a temporary arrangement, it will be far more interesting to use an anarchic approach. Just to see what happens, to see what sort of conflicts arise. I see it as a bit of a research project.

You are the founder of 'Rostfest', a music and art festival in Eisenerz. Can you tell me about how that came to life? In 2003 I saw a fascinating exhibition in Berlin called 'Shrinking Cities'. It really inspired me and I realised that this is also a pressing issue in Austria.

Eisenerz is a mining town that was booming in the 20th century. Driven by technological advances, there has been a huge decline in jobs and people are forced to look for work elsewhere. We picked Eisenerz because it's one of the towns with the biggest decrease in population. The overall concept was the same as before in Graz. How can you use space as a resource? How

TOP The castle is built in renaissance style with a three-storey arcade courtyard.

RIGHT Rainer and a group of friends share a living area of 1,800 m². In summer, they also benefit from generous outdoor spaces, where they host communal dinners and parties

can you create space for creativity? How can you initiate sustainable, long-lasting impact?

Have you ever thought of developing the site here as a group? Yes. When the owner told us about his plans to turn the place into flats we proposed quite a radical concept. We had a Swiss couple who were willing to invest a substantial amount of money, and the owner was really intrigued by our plans, but he has to think about his children who will inherit the place. It shouldn't be a burden for them, which is understandable as well. We would have loved to take over and maintain the property.

So are you still involved in the planning? We're still discussing it. But personally I can't imagine living here once it's converted into 16 conventional flats. My main criticism [of the plans] is that there are no communal spaces at all. No communal kitchen, no workshop or studio. Going from something very open and communal to this very conventional housing concept? I don't think I could do that.

What is the best thing about living here? I really like the combination of co-living in a rural setting. You still have some sort of social life or exchange with like-minded people that you're used to in the city. I know a few people who followed their dream and moved to

the countryside as a family, but then ended up feeling pretty isolated and really struggled with that. So it's the best of both worlds really.

Living space in cities is getting so expensive, and there is less space that can be developed. Here, we have this sense of opportunity, freedom and space to create. In that sense I think the countryside will become more relevant.

Have you thought about a rural co-working space? For us that would be ideal in Eisenerz, like a summer retreat. 'Sommerfrische Neu'! In the old days, the aristocrats from Vienna used to stay in the countryside for a month, somewhere near a lake or in the mountains with good air. They used to bring their servants or secretary. Today people have their laptops and, if your work is flexible, you can be anywhere. Having the option of working in a different environment for a while, like a remote co-working space, I think that would be really exciting.

→ SCAN.AC

RIGHT Rainer enjoys the combination of worlds that cohabitation in the castle provides: a rural environment, but with the constant opportunity to socialise with like-minded people.

ERIC VIVIAN & YOSHIKO SHIMONO designers

'Hustling, taking our daughter to daycare, rushing to work, working really hard, rushing to pick her up again, and then feed her and put her to bed. I was like, "what are we doing this for?"'

Portland → San Francisco → **Miyanoura, Yakushima, Japan**
population 3,000

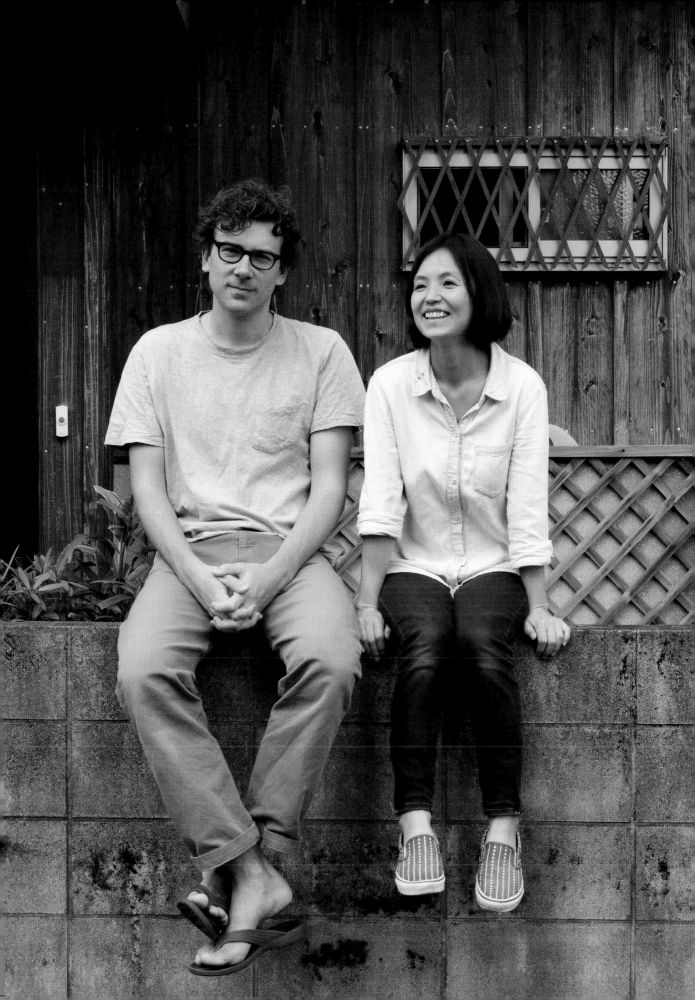

After several years spent living and working in some of North America's most desirable cities, including Portland and San Francisco, YOSHIKO *and* ERIC *decided to move to Japan. But rather than opting for Tokyo, they chose Yakushima — a subtropical island off the southern coast of Kyushu. Attracted by the relaxed vibe and entrepreneurial spirit of the island, and Yoshiko's family history in the area, the pair have found here a simpler, slower life, allowing for more time to pursue the things that matter to them most — family, friends and creative freedom.*

What brought you to Yakushima?
ERIC VIVIAN: After 5 years in San Francisco our first daughter Miyako was born. We had been thinking about moving to Japan for a little while, and having a child made us crave somewhere a little simpler to call home. So we thought, 'why not Yakushima?' Yoshiko's dad grew up here and after retiring he and his wife moved back. Having family close by would be a huge help, and at the same time we could be close to the island's awesome nature.

YOSHIKO SHIMONO: Raising our child in a big city didn't make sense to us anymore. Hustling, taking her to daycare, rushing

to work, working really hard, rushing to pick her up again, and then feed her and put her to bed. I was like, 'what are we doing this for?' I wanted to have more time for her. I wanted a more flexible schedule.

EV: Yakushima seemed a great place to relax a little bit, to experiment and try out new things. It would allow us to focus on our own creative projects. We didn't want to be someone's employees anymore.

We had visited Yakushima a few times, but it still felt a little risky. You don't get the vibe right away. We didn't know what we were getting into. Eventually we moved, 2 years ago.

What made you crave a simpler life?
EV: Our life was really hectic. Trying to juggle

TOP The view over Miyanoura village.

RIGHT Yakushima is famous for its lush vegetation and moss-covered forest, and is a designated UNESCO world heritage site.

NEXT SPREAD Looking down on Anbo River from Matsumine Bridge. Eric and Yoshiko's flexible schedule allows them to make the most of the natural beauty surrounding them, and often take their children swimming in the ocean, hiking or kayaking.

work demands and childcare was quite challenging. I also started to feel weighed down by all our possessions. When you have the space you just fill it up. Before we moved here we had a big clearing out. We had to learn how to get rid of stuff. It felt so good to see it leave the house — we pretty much sold everything.

YS: Instead of owning a lot, we just wanted to have quality things. If you're surrounded by things you love, you take better care of them and they will last longer. Today everything is disposable, even clothing. We tried to change our approach to that, but we're still working on it [laughs].

Can you describe what your work life looks like? EV: We have a studio together. This year we had a lot of graphic design projects and I've been doing most of the design work. Yoshiko does a lot of strategy and project management. My Japanese is pretty basic, so she has to write all the emails [laughs].

One of our current projects is with Yakushima's first craft brewery, which we are super excited about. We are friends with the owner and are designing the labels for them.

We're also spending our creative energy on doing our own products. We want to build a guesthouse — we don't have the land yet, but we got this idea that we want to build a place for our friends and other visitors to stay.

Have you succeeded in having a more flexible schedule? YS: Yes, definitely. Life is less stressful. It's a much healthier environment for me in that sense.

Miyako is in school, but our younger daughter Kyoko is at home with us. She'll often sleep or hang out in a playpen next to the office. She'll probably go to daycare when the next school year starts, but for now we've decided to spend more time with her. That's something I couldn't do with our first daughter. I'm enjoying the time to really bond with her.

EV: With setting up our own creative business we are more in charge of our time. It allows me to go surfing when there are waves, and if I feel like going for a run I just do it.

YS: We often have dinner with grandma and grandpa. They live 5 minutes away, right by the ocean. And there's a river where the kids like to play. In summer we often pick up Miyako from school and go to the ocean before dinner. That is such a luxury to me.

Do you have many Japanese clients?
EV: When we first moved here I was still working for clients in the United States. Now we have a network here in Yakushima, so we mainly work for businesses based on the island. A lot of our friends here are trying to do their own thing. You kind of have to – there are no jobs here. It has been great having direct access to the people that own these businesses. You're not dealing with a big corporate structure.

Do you feel there is more freedom to experiment? EV: I think so. At least personally I have the opportunity to try new things. You just have to create your own fun things to do. It's not like in a big city where you can go out to a club or a bar. Here, if we want something like that we have to make it ourselves. I started VJing for a friend of mine, who is a DJ and throws regular parties. It's something I had never done before, but it's really fun.

YS: It's such a small community, but there is a lot going on. People are really good at creating their own events. There's a great DIY spirit.

How easy did you find it to connect with the local community? YS: I felt it was easier than in San Francisco. That was quite surprising to me.

EV: I wasn't really pounding the pavement to find design work. It just all happened very organically, which was cool.

For example, the first time I went surfing here one of the locals started chatting to me. His English was really good, and he had been a sushi chef in Los Angeles for a while. He told me he was doing a new restaurant, and I explained that I had just moved here and that I was a designer. I gave him my business card, and two months later he asked me to do the logo and signage for his restaurant.

We just connected and we had a lot in common. Now it is one of the best restaurants in town and has become such a hub for the community. We're getting a lot of work through that network. And he has also become one of our best friends.

YS: We haven't really promoted ourselves or actively looked for new projects, they just keep coming. It's all word of mouth. That's been really nice.

It sounds like there's quite a big creative scene on the island. YS: There is a big influx of people from other parts of Japan. The Fukushima earthquake prompted a lot of people to rethink their lives. People moved to Yakushima because they were looking for clean water, they wanted to move away from the city with their kids. There are some people who grew up and have always lived here, but there are quite a few who have lived all over the place and travelled the world. They've been exposed to urban life and want to bring some of that creative culture to the island.

Do you feel you can bring something new to the area? EV: The experience of working in Portland and San Francisco is certainly a plus. I think clients like that about us. However, you can't just transplant a trend from the city to here. I think it's more about our approach or our thinking that is a little bit more contemporary.

YS: We can bring a new perspective to the island. Not just through the design work we're doing, but hopefully also through the guesthouse. We hope to inspire visitors, showing them our way of life. Our clients sometimes don't know how to utilise the branding we've created for their own business. If we can do a good job with the guesthouse we can lead by example. It might allow us to attract more

TOP LEFT A stroll through the neighbourhood. Life is much slower and quieter for the family since leaving San Francisco.

NEXT SPREAD LEFT Eric and Yoshiko used the move to Japan as an opportunity to downsize – selling many of their possessions before leaving the US.

NEXT SPREAD TOP RIGHT Nagata Beach, Yakushima's main nesting ground for sea turtles.

NEXT SPREAD BOTTOM RIGHT Eric sketching for a new brand design. Most of the couple's clients are local businesses and share the same entrepreneurial spirit as Eric and Yoshiko.

ERIC VIVIAN **'I started to feel weighed down by all our possessions'**

customers and hopefully the local economy will benefit as well.

How does living here affect your creativity? EV: The thing I'm getting better at is to not overthink things. Before I would always revise and question my work. Maybe it is because there are not so many eyes on it here. I just do what feels good and put it out there. It's fun to get into launch mode faster.

YS: We try not to spend too much time on upfront strategy and research – not to over-analyse. That often brings the best result. Mostly we work directly with business owners so we just brainstorm together. The process is a lot simpler.

I can imagine this direct way of working is quite rewarding. YS: It's nice, but the downside is not everybody knows what design is all about either.

EV: A marketing director who's had all this training is totally different to somebody who just wants to open a restaurant or something. They've never thought about their target audience or things like that. We do a lot of client education and they appreciate that too.

What have you found most challenging about living in Yakushima? YS: In the city there's an immediate response to everything. You're used to instant gratification. Here you need to learn to go with the flow.

EV: Weather on a subtropical island can be extreme – this is the rainiest place in Japan. I never had to put up storm windows for a typhoon before, for example.

YS: I am learning how to be Japanese again [laughs].

How do you feel about Japanese culture? YS: Some of the older generations here are very conservative. Instead of asking what I do for a living they ask me what my husband does, assuming that I'm a housewife. That was interesting. Initially I struggled, but I came to the conclusion that I shouldn't change who I am, no matter where I live. Once I realised that it got a lot easier.

Also those family obligations that I'm supposed to do. I just learned to say no. They accept that too.

Do you feel people are open-minded towards foreigners? YS: Yes, especially at community events. Every village has a sports day, so we just joined in. We were some of the few young people in our team, but it was a lot of fun. They loved Eric – lots of people were telling me afterwards how nice my husband is.

EV: That doesn't happen in a big city. Here the whole neighbourhood gets together to create these community events. We got to know everybody so fast.

In San Francisco everyone we knew was an employee at another design firm. The diversity of the people we know here is a lot bigger. There's our 65-year-old guitar-playing neighbour – I sometimes have a beer with him, or our friends who are also clients now. Everyone is entrepreneurial; everyone is doing their own creative thing. It's so nice to be surrounded by this kind of support system.

YS: There is also a lot of food sharing. When we go for a walk with the kids someone might just give you a huge bag of oranges for free, or whatever else they're harvesting that month.

EV: There's lots of amazing fresh seafood around here. Sometimes people show up with a huge squid they've just caught [laughs].

What are your plans for the future? YS: We want to get the guesthouse going and use our creativity for our own products. We hope to inspire others and show that there's an alternative way of living.

Another idea is to create a new guidebook for Yakushima in English, or maybe even bilingual. Since Japan has a big souvenir culture, we also want to create souvenirs made from local ingredients or materials.

EV: Yakushima has a slow, quiet way of life. It's easy to get lazy. It's important to keep yourself motivated and just keep going [laughs].

→ ERICVIVIANDESIGN.COM

RIGHT Although Yakushima is one of the rainiest places in Japan, getting hit by several typhoons every year, Eric and Yoshiko love being closer to nature and the ocean.

RICCARDO MONTE architect, painter and sculptor

'I think in the city we are losing touch with our culture, our ancestry, and the knowledge of making'

Milan → London → **Ornavasso, Piedmont, Italy** population 3,400

RICCARDO *was living in London and pursuing a career in architecture when a sudden change in circumstances prompted him to rethink his situation. He left the city on a whim and, after contemplating a period of travelling, realised he could find everything he was looking for much closer to home. In the quiet hamlet where he was born, overlooking the Italian Alps, Riccardo now divides his time between building an architecture studio, drawing, and making timber sculptures. While living in a place where everyone knows you isn't always easy, the benefits that come from being closer to nature seem reward enough. And if things get tough, mountain solitude is just a short distance away.*

What brought you back to Italy? I had been working in an architecture practice in London for 6 years and was doing a university degree. The day I passed my exam, I was made redundant. For me, it was a sign to move on and change something in my life. I went home and packed everything. I sent everything to Italy with no intention of coming back to London.

First I went to Sicily for 3 weeks to visit a friend. Then I came back here to see my family. I wanted to travel the world, but I realised I had everything I wanted here. Why go somewhere else? I had been missing the mountains and the solitude.

Can you describe your living situation? I live in Ornavasso, my birthplace, which is a small village at the foot of the Alps. I share the house with my mum, and also have my studio there.

I also have a cabin in Alpe Cortevecchio, a small settlement in the mountains. It's very isolated; there are only 15 huts. I decided to

spend the whole of last winter there, without anybody around. Now I go up there regularly to get inspired or enjoy nature.

The cabin is very simple: it has two bedrooms, a kitchen, living space, and a bathroom. The house was built about 200 years ago, but was burned during the war. My grandfather who was an architect rebuilt it in the 60s with a small extension. It's very well designed.

There are not many facilities. I had to do a lot of DIY to build insulation and prepare wood for the winter. I have a wood-burning stove that I use every single day.

How do you spend your time up in the mountain cabin? I draw a lot. I just use what I have. I started to use the charcoal from the stove for my drawings. I've also been working on some timber sculptures.

I come down to the valley every 2 weeks to get food and supplies, and do some work on my studio. Often people come to visit me, too. For my friends it's a nice balance to their stressful urban lives. There is something very special about this place. As soon as people get up here they forget about everything else. You just focus on what's around you – it's a simple life.

What else have you been up to? I built a studio for myself. I completely refurbished the space – new doors, windows, floors and ceiling. I have some architecture and interior projects going on, and I'm doing my drawings, which I have started to sell. I also rent out a room in the house in Ornavasso through Airbnb.

I'm in the process of buying another little house, which is going to be my next project. It's right in the middle of the forest by a cliff, an incredible setting. It used to be a stable, just stone walls and a stone roof. It might become another workshop.

My father passed away in June. It's another reason why I try to be around more and look after my mum. It's good that I'm here.

What do you like most about your life here? Living in a small community can be good and bad at the same time. It gives you the feeling of being home which is nice. However, people don't always understand what you are doing – I am one of a few architects in the

PREVIOUS SPREAD Riccardo working on a timber structure with local chestnut wood, watched over by his ever-present dog Lupa.

TOP LEFT Previously used as a goat stable, this stone house hidden in the forest is being transformed by Riccardo into a workshop.

BOTTOM LEFT Riccardo's simple mountain meal: polenta, latte e formaggio.

NEXT SPREAD Riccardo's studio in Ornavasso is part of an 18th century house.

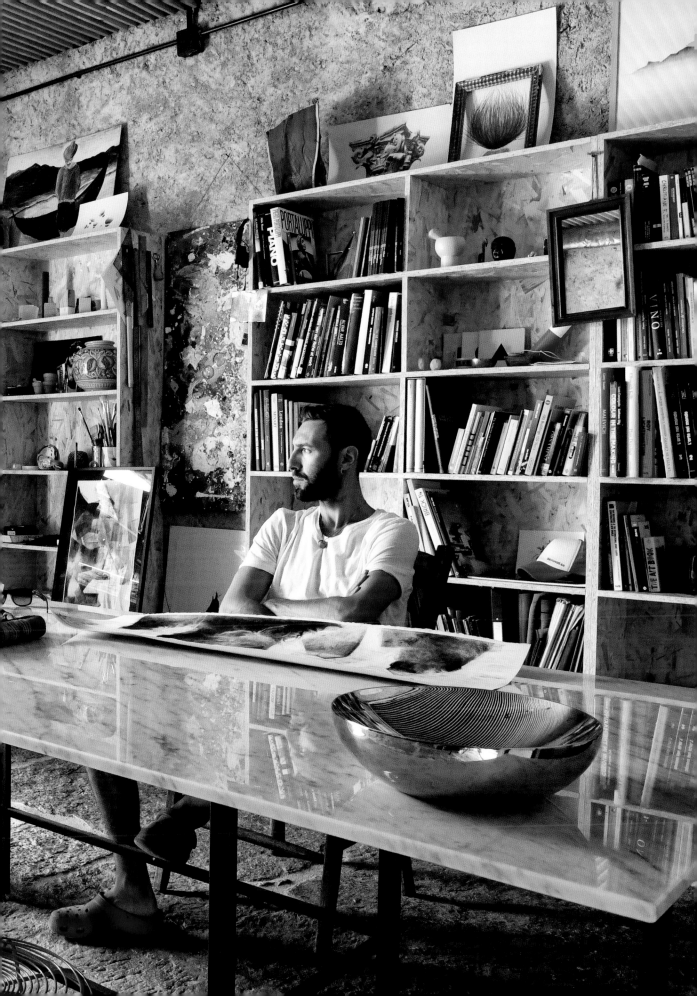

village. In the nearby area there are a lot of painters and artists, so I am trying to build more connections that way as well.

But I like having conversations with all sorts of people. Everybody has something to teach me. I've been working with a builder who is in his 80s. He was on the top of my roof with a chainsaw to make a new chimney. He's amazing [laughs].

My neighbour here is an old lady. She only speaks to me in the local dialect. I have always understood it, but I'm getting more familiar with it now. She is teaching me a lot about living in tune with the seasons, just with what nature gives to us. I want to rediscover all of this.

I think moving here has helped me rediscover simple life and real values. Using materials that I find here, reviving traditions, working with local people.

What do you mean by 'real values'? Nowadays a person in Australia or in Japan can be very much like me. I think in the city we are losing touch with our culture, our ancestry, and the knowledge of making – the regional nuances.

I think you can be happier living a simpler life. In the city you always want more, you are never satisfied with what you have.

Do you miss the city at all? I do. Whenever there is a good exhibition or the opportunity to visit my old professor I go to Milan. It's good, but there is nothing like the energy you feel in London. Everybody is very focused on what they want to do. I get recharged every time I visit, I feel motivated. London pushes you. You need the vibe of the city sometimes.

Do you think you can bring something new to the area? I try to apply what I learned in London. For example, professionalism is something Italians need to get better at. Another thing is the way you approach a project, the way you understand architecture.

Has your relationship to nature changed? I appreciate it more. The first thing I do in the morning is walk 2 minutes up from the cabin. The view is incredible – you can see lakes,

and I've got the Alps in front of me. I will never get tired of this. Every day it feels different, even if it's the same view, the same spot, it is very inspiring. Then I think of myself in the office in London and I am happy not to be there [laughs].

I love stepping out into the darkness at night. I listen to the silence. I can hear the sound of my bones. It is incredible, especially in winter, it's so quiet.

You need to get used to being up in the mountains by yourself. One night a big owl was trying to snatch this little cat that had been coming to my cabin for food. In complete darkness this big bird was flying above my door. That was quite intense.

Does the house have electricity? No, there's no electricity. There is a gas container for cooking and hot water. I usually cook on the fire stove. I have a generator so I can plug my computer in, but I rarely do it – it's quite noisy, and I don't want to disturb the environment. I might put up a solar panel at some point.

In January we had a period of minus 10 degrees during the day. The water was about to freeze. I had to keep the taps open night and day. The sound of running water became part of the environment [laughs].

You said people are becoming more similar regardless of where they are from. Why do you think that is problematic? I think every place should have its own culture – informed by the environment, climate, and resources. I mean culture not just on an intellectual level, but also in terms of history and ancestry, the use of local resources, and understanding of the territory.

One hundred years ago this area used to be farmland. Now nobody wants to be a farmer

TOP RIGHT Alpe Cortevecchio – a settlement with only a handful of houses, is the site of Riccardo's alpine refuge.

BOTTOM RIGHT Riccardo spent the whole of last winter in his cabin in the Alps – a big contrast to his previous life in London, working at an architecture practice in the city.

NEXT SPREAD LEFT Riccardo is rediscovering the traditional methods of working with native timber varieties through conversation with local craftspeople.

RICCARDO MONTE 'You need to get used to being up in the mountains by yourself. One night a big owl was trying to snatch this little cat that had been coming to my cabin for food'

anymore. It's not a desirable profession. People prefer to work in an office in Milan, so a lot of knowledge is lost.

So is it about preserving knowledge?
Yes, exactly. Preserving knowledge, even preserving the language, the local dialect.

For example, I started to live according to the lunar cycle. There is an ideal time to forage for mushrooms. Trees behave differently depending on the lunar phase. It is best to chop wood for construction during the waning moon, whereas burning wood should be chopped during the waxing moon phase. The wood really burns much better.

How do you know about these things? I've learned from the locals. I love talking to the old people in the village. I find mushrooms and chestnuts for them, and they give me knowledge in exchange. I learn much more from the local shepherd than I would from a banker working in the City of London.

What are your plans for the future?
I want to do what I like to do, with enthusiasm, passion and love. Life is too short to not enjoy what we do. I would like to push my art, painting and sculpture, and also establish my own architecture practice. Working with the locals and applying the experience I gained in London is my real strength.

I never plan so much for the future, but in August I will become a father and things will get even more exciting [laughs].

PREVIOUS SPREAD TOP RIGHT A charcoal sketch in progress.

PREVIOUS SPREAD BOTTOM RIGHT Alpe Cortevecchio covered in deep snow.

TOP Oak and birch wood tables — all made by hand from locally sourced timber.

RIGHT The view down to Alpe Cortevecchio. Riccardo's cabin is part of the cluster of houses visible in the foreground.

→ RICCARDOMONTE.COM

BAI GUAN cartoonist **& HUANG LU** photographer

'I used to think life at a slower pace was lazy, but now I realise it is much more fulfilling. People are much more grateful for what they have'

Shanghai → Beijing → **Bei Shi Cao Zhen, Shunyi, China** population 3,000

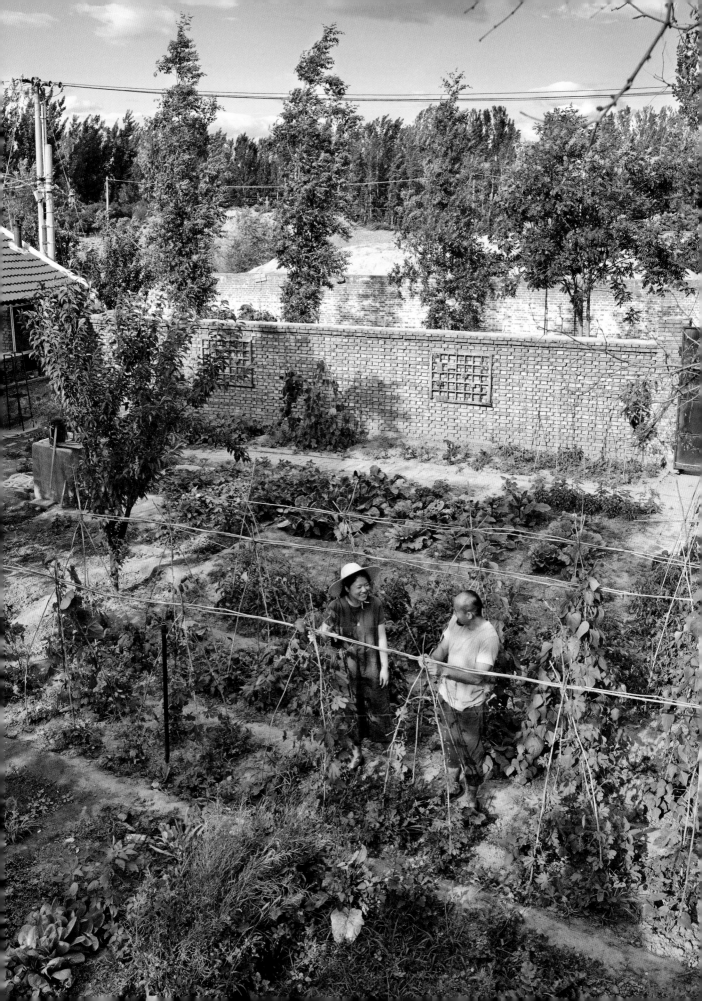

When LU met GUAN, he had just left his job in Shanghai and was travelling around China by bike. Both weary with their lives in the city, the pair had much in common — and stayed in touch for the duration of Guan's 3-year journey. On his return, they decided to move to the countryside together, and pursue the quieter life that they both craved. Five years on, in the foothills of Yanshan mountain 50 km outside Beijing, they've established a self-sufficient existence that has changed both their perceptions, and those of their traditionally minded parents, of what you need to be happy.

How did the two of you meet?

HUANG LU: Guan had just quit his job in Shanghai and started cycling around China in August 2010. I was based in Shanghai, working for a magazine publisher in the finance department. We met on Lantau Island in Southwest Hong Kong. I was on a mini work break and he was cycling through there.

Guan went on with his bike tour for another 2 years, but we kept in touch. In that second year I left my job and became a freelance photographer. When Guan was finishing his tour I took a break and we met up in Lhasa to go trekking. It was the first time we actually spent time together. He was very patient and kind.

After leaving my job I had been thinking about moving to the countryside. Guan felt like the perfect partner for the sort of life I wanted to lead. I emailed him in September 2012 and asked if he would move to the countryside with me after finishing his tour. He got back to me 3 days later and said yes. We only really started dating in November but things moved quickly. In the New Year we started looking for a house in the countryside.

What made you want to leave the city?

HL: I was fed up with it. I felt like I was on the go all the time. I used to think life at a slower

pace was lazy, but now I realise it is much more fulfilling than it seemed. People are much more grateful for what they have. Another big reason for me was to grow my own food.

BAI GUAN: I grew up in a farming village so I always had a natural preference for the countryside. When I first moved to the city I was fascinated by it. I dreamed of working in an office building and becoming a white-collar worker.

I worked as a game designer, and for a while I felt I was on top of the world. But I soon realised the sacrifices I had to make were huge. I worked late every day, and it was very tiring. After years of hard work, I asked myself: 'Are you getting what you want in life?' The answer was no. I was just following the rules. One day during my sardine-like commute it dawned on me that I didn't enjoy city life anymore. The only things I miss are the libraries and museums, but they are not exactly essential to my life.

My bike tour around the country changed me unexpectedly. I realised what we need to survive as human beings is very simple.

How did you find this place?

HL: One of my friends owns a house in the area and we used to come here on weekends. The place is perfect in the sense that it is quiet, but close enough to the city. We are not totally cut off from the world.

Where we are now is a village in Shunyi, close to the mountains, and by a reservoir. We saw around 30 houses in the neighbourhood and finally settled on this one. It's a small village, but most of the younger generation has moved to the city so there are mainly elderly people left.

How has your life changed since moving to the countryside?

HL: I feel more relaxed and it has opened up my eyes to more possibilities.

The most unexpected reward was to do with my parents. They weren't particularly supportive of my decision to quit my well-paid job and move to the countryside. They chose my career in finance for me and I've rebelled against it for a long time. I did not have a good relationship with them.

After I moved here, I've made them see a different way of life. Like all other Chinese parents they used to be very concerned and

PREVIOUS SPREAD RIGHT Lu and Guan in their bountiful garden — a luxury that would be impossible to attain where they lived in Shanghai.

LEFT There are no restaurants in the village so Lu and Guan always cook, believing the food tastes so much better because the ingredients are all home-grown.

competitive [with other parents] about how much I earn. They don't do this anymore and seem to be much more relaxed. My mum especially started to enjoy life more. She joined a choir and travels more. She realised that I am happier and healthier making this lifestyle change and this opened her eyes to live her own life differently.

I love that we have our own land. Seeing our crops grow gives me a sense of contentment, knowing that we will always have a full belly. It also means your body and mind can be more in tune with the seasons.

We are busy growing our own food during spring, summer and autumn. Winters are cold and snowy. It's a quiet and reflective time for us. We are not needed in the fields so we tend to use this time to travel.

What have been your biggest challenges? BG: There are a lot of problems you don't have in the city that we didn't quite anticipate. For example the insects, the sewage problems, and also our electricity gets cut off from time to time. Our water gets cut off at 10 o'clock every night.

HL: I'd say there aren't any real downsides to living here, but we do get extremely busy during the harvest. We can't really leave our crops untended for too long, so we are not able to travel often. But this doesn't bother us.

Has living in the countryside influenced your creativity or changed how you approach work? BG: I think it would be incredibly hard living in the city doing what we do. As a freelance cartoonist and illustrator, I wouldn't be able to survive. Most of the people in my industry need a full time job to support their creative work. The living cost in the city is too high.

HL: Moving to the countryside has given me more creative freedom. As a photographer, it has helped me to slow down and learn to take more time to observe my subjects. My workload has decreased as well. I used to be away from home for work for 10-20 days at a time, paying for a flat that I didn't actually get to use.

I feel more settled here, living with the pace of the seasons. I don't work in April, as it's the busiest time of year on the farming calendar. I don't feel moving to the countryside has

impacted my creativity, but it did change my creative flow – it's slower in a way, yet I feel more creative. It's helped to increase my artistic sensitivity. Having less work means that I don't get burnt out that quickly.

BG: Living in a rural environment has influenced my creative topics. Now I'm drawing about our annual harvest, as opposed to my daily commute for instance.

Some people say living outside the urban context enabled them to find their own voice. Can you relate to that? BG: I think we already found our voice or style before moving to the countryside. We are working with something that is already within, the environment just provides better conditions for it.

HL: I feel much more connected to my environment so that is reflected in my work. Some people criticise the photographs that I take on my phone because they are not as professional looking. I actually like those 'real' photos because they show life as it is. I don't want to glorify our lifestyle.

How easy did you find it to connect to the local community? HL: It wasn't a problem at all. We quickly became part of the community, partly because we grow our own food. We were doing so well that our neighbours started to come to us for seedlings and advice.

How have your friends reacted to you moving to the countryside? HL: Our friends weren't really surprised; a lot of them are working and living in a similar fashion. It's becoming more common for freelancers like us to move away from the city. Because of rising rents many people can no longer afford to live in the city. Freelancers especially seem to no longer see the need to be there.

BG: What we are doing is definitely still a niche in China. People in general want to buy

PREVIOUS SPREAD The autumn sun shining through their humble front room.

TOP RIGHT Guan working on a wooden structure to support lanterns.

BOTTOM RIGHT A mantis found in their vegetable patch.

BAI GUAN 'We live in an environment where fashion is our smallest concern. There is no need to dress up like people do in the city'

a house in the city. But I think the desire to be close to nature is in our DNA. It's an idea that has been celebrated over thousands of years in arts and literature, and by poets such as Tao Yuanming.

What's your approach to social media? BG: Social media is a tool for self-actualisation, it's a channel to showcase our work. These platforms help us make a living, and also make us feel recognised. However, we are aware of the negative impact it can have. I actually want to reduce my time spent on it.

How has your consumption changed? HL: I've definitely become better at using the resources available to me, especially when it comes to cooking. There aren't any restaurants in our village so we always have to cook. The food we grow ourselves tastes so much better. We want to use it well.

BG: We live in an environment where fashion is our smallest concern. There is no need to dress up like people do in the city, even just for a quick trip to the convenience store. The urban environment encourages over-consumption and you don't even realise it's happening.

Have you become more self-sufficient? HL: Yes, we are much more self-sufficient now. To me, moving to the countryside means a life in the field. It is what I wanted to do when I decided to move here. We had some help from Guan's dad and I learned a lot from him. Now we are in our second year of being totally self-sufficient.

Just like nature, I like the idea of going with the flow. Everything is a process, so there is no need to be afraid of failure.

Has living here affected your health in any way? BG: Living in the city was not good for our health. I had a cold all the time but since moving here my symptoms disappeared and now I rarely catch a cold.

When I was living in Shanghai, the quality of my sleep was very bad because of the constant noise and light pollution in the city. One of my friends can't sleep without the TV or lights on — the city conditioned him. We are like

fruits grown by artificial lights to fast track our growth, over-stimulated and in a constant state of restlessness. It's not a good recipe for life.

What are your plans for the future? HL: We would like to have kids. Guan wants to finish his book series. We just want to enjoy the life we have now and continue to grow our own food, and maybe build a house of our own.

→ HL WEIBO.COM/MYROAD123
→ BG WEIBO.COM/BAIGUAN1978

PREVIOUS SPREAD LEFT Having her own space to grow food was Lu's biggest motivation to move away from the city. She also grew a new following online by sharing her lifestyle on China's social media platforms.

PREVIOUS SPREAD TOP RIGHT Guan keeps fit using the facilities in the village. Here he shows off his skills on an evening walk.

PREVIOUS SPREAD BOTTOM RIGHT Preparing a traditional Chinese couplet ready for the New Year celebrations.

RACHEL BUDDE herbalist, founder of Fat and the Moon

'I learned more about being a human by being around plants, animals and wild landscapes. It just gave me a wider perspective'

New York → Oakland → **Nevada City, California, United States**
population 3,100

RACHEL *lived in Brooklyn for 11 years, honing her skills as an artist while feeding a growing interest in mythology. At first providing inspiration for her art practice, it was this interest that gave way to a realisation: she had lost a connection to her surroundings that formed a part of her Slovenian heritage. Rachel's resulting transition from New Yorker to Californian, and artist to herbalist, was inspired not only by a desire for a more conscious life, but a deeper calling to nature and its role in her ancestry.*

What made you want to leave the city? Leaving New York was difficult for me. I was developing my art career, and was fresh out of graduate school, when I felt a calling that was connected to plants and healing. I think of that time as a fork in the road of my destiny; one road led to one life, while the other led a different way. Once I left the city to live on a farm, I felt flooded with purpose and inspiration.

What prompted the shift from art to plants? What really informed my art practice was mythology. A fundamental part of mythology is how people relate to their landscape, the animals that live there, and the plants. I realised that I had no connection to any of that. I was interested in mythology but wasn't really investigating my place in this eco-system.

When I began studying permaculture I heard an idea that some weeds growing in urban areas have medicinal properties correlating to the illnesses people suffer from in the same landscapes. That was a really powerful discovery for me — seeing this connection to nature, even in the city.

First I moved to Oakland, but l felt a strong desire to have more plants and animals around me than people. I ended up moving to a very small town in Northern California called Point Arena, with a population of about 500

people, where I lived on a farm. I learned more about being a human by being around plants, animals and wild landscapes than I did from being around other humans. It just gave me a wider perspective.

How did you get to Nevada City? I really loved Point Arena. I lived in a tiny house that was off the grid. I learned about myself deeply during that time, but it also felt a bit lonely. My partner and I broke up, and I wanted a bit more of a community. Nevada City seemed like a happy medium. That's how I landed here, in the hope of buying a farm at some point.

When did Fat and the Moon start? It started in Brooklyn in 2011. At the time I started to get really alarmed by the toxicity of the products I was using. If you want to see something in the world, as an artist, you make it. That's how it got started, that's what is at the core of Fat and the Moon.

My background as an artist, feminist and herbalist converged. Our products are alternatives to the toxic ingredients and toxic messaging ubiquitous in body care products. We provide plant based body care potions that support self-care and self-love.

How did you learn about plants and their properties? When I came to California I studied with various herbalists and ethnobotanists. My family is from Slovenia and herbalism is part of the ambient culture there, like it is in many countries outside America. For most people it's just practical to use plant medicines.

Four years ago I started to research the medicinal plants of Slovenia but also their uses within my family, and that's turning into a book. It was really fascinating to learn the stories about plants and how people related to them, how they fit into their mythology and their culture. That's been a humbling part of my education, and taught me to revive our relationship with these old allies.

We need to realise that we are nature. This dichotomy of nature and culture is a construct. We need to see our relationships with plants, even weeds, as alive and full of potential — and we can do that no matter where we are based.

PREVIOUS SPREAD Nevada City, located in the foothills of the Sierra Nevada, is surrounded by a great diversity of ecosystems. The beauty and richness of the natural landscape provides a huge resource for Rachel.

LEFT Rachel now lives with her partner after her own home burned down — the result of an electrical fire.

RACHEL BUDDE 'In some ways I am just as busy as I was living in New York. But what feels really different is my ability to go out and be in the middle of nowhere without any people around'

How often do you go to the city? I try to go to New York once a year. With my business I travel to do workshops and teach in other cities and I'm grateful for that experience. I think part of my inner conflict is that I want to live in the middle of nowhere, grow plants, make medicine and not talk to that many people. And then there's this other part of me that wants to be in the middle of a thriving metropolis because there is so much going on and there is this real energy. For me, it's about being a hybrid. Embracing that has been helpful – knowing that I do need both.

How different is your day-to-day life now compared to New York? In some ways I am just as busy as I was living in New York. My work is multilayered. I am writing a book, I am running a business, and I am pregnant and want to have a family. But what feels really different is my ability, my privilege, to go out and be in the middle of nowhere without any people around. It feels very nourishing. The beauty of the natural landscape here is a huge resource for me.

How easy did you find it to connect with the local community here? I came into a wonderful community, so I feel very lucky in that sense. Bringing my art or business with me was a great bridge. Fat and the Moon was the entity that helped me gain access to the community. Now my business is here and I've hired people, it's something I could bring. And that feels really good.

Do you miss the city? I miss parts of it. I miss public transportation [laughs]. It's so funny, I would never have said that while I was living in New York, but there's just something about it. You get to experience all these different characters.

But as I get older and am about to become a mother, I love the idea of my child having access to a wild landscape, a place where there's not constant stimulation. That is really important to me. I feel the right way for me to enjoy cities is to go for 1 or 2 weeks, to London, New York or LA, and then come back here.

Do you grow the plants for your products yourself? Some of them. I work with local farms to source some of the plants and we work with a company in Oregon as well.

My home burned down in January. That was a real shift in my life, in big and small ways. Now I live closer to town, but my hope is to buy a farm to grow the plants for Fat and the Moon in the next 5 years.

What happened to your house? I was away in Hawaii on a writing retreat for a couple of days. Nobody knows exactly what happened, but it was electrical and happened in the middle of the night. My home completely burned to the ground. It was pretty intense. It's been a huge learning experience for me; of course it was devastating, but it's also given me such a different sense of what home is. My sense of belonging had to come from belonging to myself. I think it's an experience I'll take with me for the rest of my life.

And honestly, I don't think I would have gotten pregnant if it weren't for the fire. That's how fire works in the natural landscape, it brings fertility. It brings total destruction, but from that destruction comes new life.

When you are in a landscape where the cycle of life to death is more visible, it starts to affect you deeply. The elemental parts of life become more natural. I think it opens you to the transitions that happen in your own life. That doesn't always mean it's easy, but it can give you a sense that this is part of life, part of nature. It's strengthening. It gave me such a different sense of worrying – the worry about something bad happening is often much more limiting than how we actually end up reacting in the moment.

Has your consumption changed at all since living in a rural place? I am much more aware of what happens to something after I have finished using it. Once I had the experience of living on a farm, eating mostly the food that we grew, and enjoying the quality of life that came

PREVIOUS SPREAD Views from Round Mountain Trail in Nevada City.

RIGHT Rachel deliberately resists the pressure to constantly update her business's social media feed. Instead, she prioritises connections in the real world, taking time for herself when she needs it.

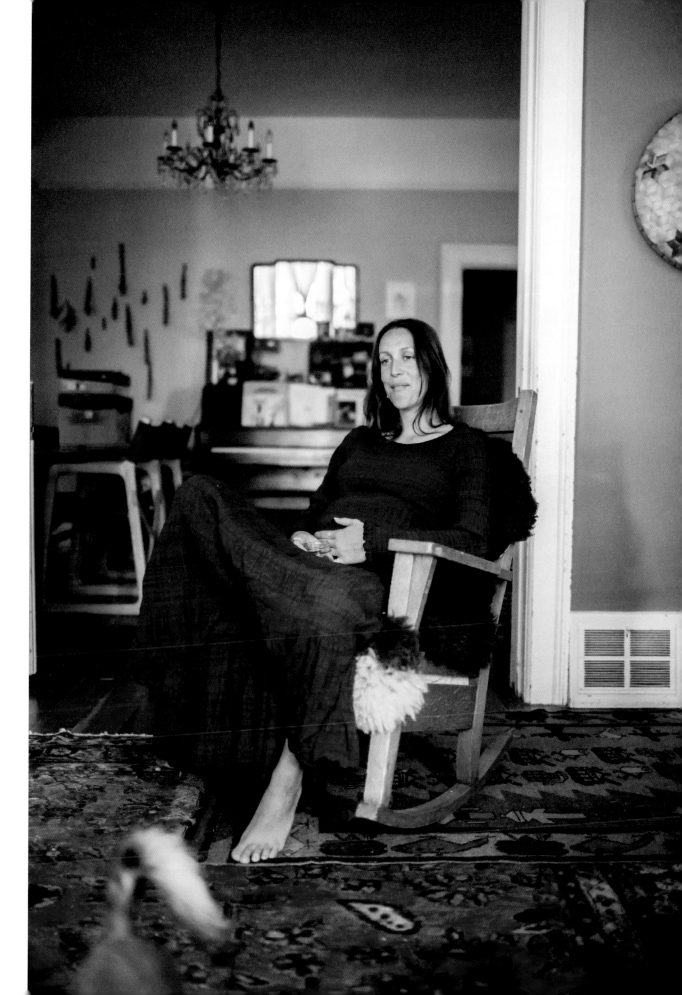

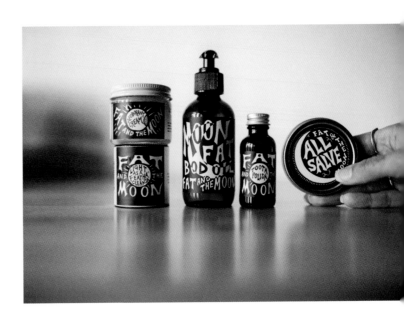

RACHEL BUDDE 'Our products are alternatives to the toxic ingredients and toxic messaging ubiquitous in body care products'

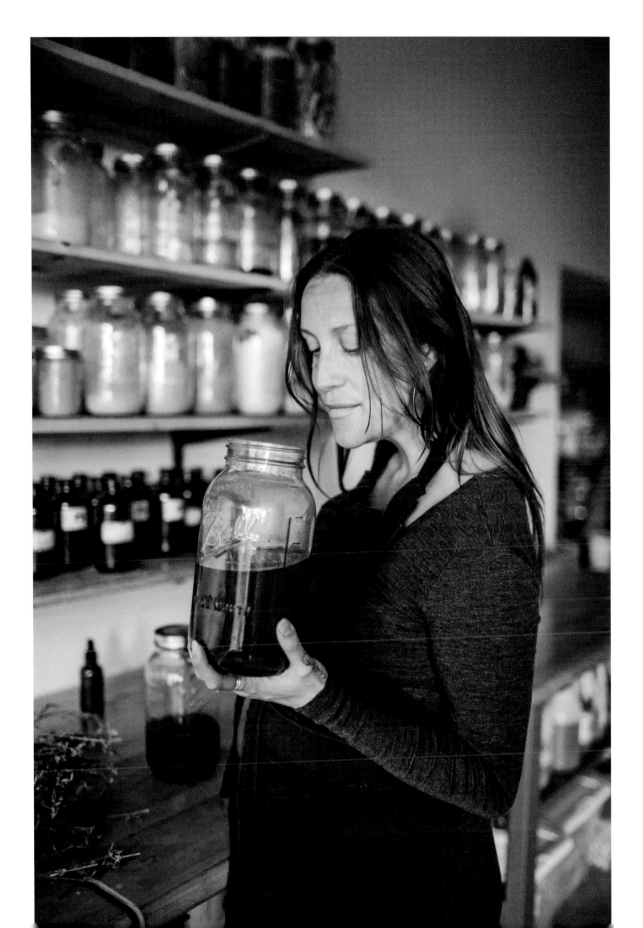

from that, I could never go back. I still love beautiful things — I love art, I love fashion — but I try to direct that interest and energy into more reciprocal, sustainable relationships with my environment.

Your products sell all over the world. Do you mainly sell to an urban customer? Actually, yes. The places that we sell the most are New York, Los Angeles and San Francisco. Our deodorant is like the gateway drug to other herbal medicine. It often prompts people to look at what they're putting on or in their bodies in a more critical way.

When we talk about sustainability it is often about restriction or having this boring, limiting lifestyle. But it is not just about the actual things that you are consuming. It's an entry point into thinking about the quality of life of the people who are producing the things that you consume. If your food or clothing is made by people who are enjoying themselves, it's usually a better experience for you too, and everybody wins.

How do you manage social media with your business? I can see the potential of social media, but I also see its shadow. I think people are craving connection and an authentic experience that social media doesn't really provide. There is no comparison between getting to know a plant by growing it and being around it every day, to learning about it via some Instagram post or buying it online.

Living with the plants I use in my products gives me a deep sense of intimacy with the environment around me. Cultivating intimacy is essential to my vision for my life, and to my vision of what Fat and the Moon offers to the world.

In a time where everything is so sped up and our energy and attention is going to so many different places at the same time, real intimacy is getting lost. We're constantly distracted.

I think that there's a lot of pressure for small businesses to be tweeting and to be on Instagram all the time. But I just feel I need to resist that. I need to take time to be with the people who I love in my life or to have walks by myself. If that translates to not having as many posts as people believe I should, then that's OK. It really takes conscious effort to do that.

What are your plans for the future? I really want to have a farm. I would love to have a space where I can teach workshops, invite speakers, and facilitate more cross-pollination between the urban and the rural landscape.

I am hoping to finish this book in the next couple of years. It is a longer term project, but one that's really exciting for me. It is very much inspired by my experience in Slovenia and the mythology there. Plant medicine and mythology is part of all our ancestry. For me, herbal medicine is about healing ourselves, healing our bodies, but also healing our relationship with the landscape.

→ FATANDTHEMOON.COM

PREVIOUS SPREAD TOP LEFT A selection of items made by Fat and the Moon — Rachel's body care product business.

PREVIOUS SPREAD RIGHT Rachel at Fat and the Moon's production space in nearby Grass Valley. The sore muscle salve infusion is made with cayenne, tobacco and St John's wort.

TOP Kitkitdizzi, an aromatic evergreen plant in the rose family, that's native to the Sierra foothills.

TOBY WARREN street artist, graphic designer, music producer and carpenter

'There's no spotlight on this place. You can do whatever you want, and you don't feel like everybody's judging you'

London → **St Leonards-on-Sea, East Sussex, United Kingdom**
population 9,000

TOBY, *born and bred in London, has always lived in the city. But when he met his partner, Beth, and they fell pregnant with their child, the couple decided to leave for the more rural reaches of the south coast of England. Settling in the quiet seaside town of St Leonards-on-Sea, they've experienced a renewed sense of creative freedom to explore new ways of expression and collaboration. The relaxed, seaside lifestyle might be appealing to some, but Toby isn't slowing down — he's intent on inspiring more local people with his work, at the same time as building the profile of the town through his combined passions for film, music, and street art.*

You're from London originally. What made you want to leave the city? I've been in London my whole life. I was ready to live somewhere else for a couple of years. My wife Beth and I both wanted to get out of London. We went on a tour around the south coast and stumbled across this place, and we both really liked it. Brighton was expensive, Margate was a bit rough, but St Leonards-on-Sea was a bit smaller and just right. It reminded us of London in a weird kind of way. It was only meant to be for 3 years.

How did moving here affect your life? In London I was working fulltime. Here there's more time for the things you want to do. You could easily have a pretty relaxed lifestyle here because it's cheap, but maybe that's not such a good thing [laughs]. Having kids changes your life anyway. And being able to bring up Nancy by the sea has been amazing.

How do you feel about working less? When you haven't got the pressure to earn money you take your foot off the gas a bit and relax. And if you're out of the whole London networking thing, people forget about you. Down here you just end up meeting locals and everybody's in the same boat. It's a really nice lifestyle, but I think you can only do it for so long if you've got ambitions to do other stuff.

TOP The large studio space in St Leonards-on-Sea that Toby shares with two other artists.

RIGHT Street art was a big part of Toby's life until its rise in popularity in London caused him to lose interest. But in St Leonards, local people's reaction to his work — in particular his paste-ups — has led to a rediscovery of the form.

What do you do at the moment?
Graphic design and music. I also do carpentry, but it's quite demanding physically, so I'm not sure I can do that for much longer. I want to learn new things as well. I'm doing a film editing course at the moment — I want to get into that. It will tie in with the music and graphics.

Can you explain your music project and how that came about?
I used to do a lot of music in the 90s. I released about five or six singles, and I actually did all right — I sold quite a lot. I went around Europe on a little tour. It was a good few years. At some point I just got bored of music, and I sold all my equipment, got a computer, and got back into graphics.

When we moved here, for some reason I really wanted to make music again. It can be bleak in the winter, and there isn't a lot going on. I spent about 500 pounds on some equipment and started renting a studio space. I wanted to have somewhere to go where I could work in the evenings. That's how it began.

Can you tell me about your studio?
It's a big warehouse space, with lots of room. It's great. I share it with two other artists. Danny Pockets is a painter and teaches in London 3 days a week. And Sophie 'Shuby' does collages and street art.

A few of your paste-ups can be seen around town. Are you still involved in street art?
I used to do it for a while, but then it got really commercial. I always liked doing something a bit out there, sort of alternative, whether it's music or art. There was just too much of it, so I kind of lost interest. It's a bit like when I used to DJ in the early 90s. All of a sudden everybody was a DJ, and their moms, and their

TOP Toby credits the success of his music project with the creative freedom he's found away from the city, and 'not being caught up with what everyone else is doing.'

RIGHT A repeat of one of Toby's paste-ups.

dogs... And that's what I thought about street art as well — it just got a bit swamped.

Does being down here help to operate outside the mainstream? I think you follow fashions more when you're in the heart of it. You are influenced more by what's going on around you. In fact, I think that's actually one of the reasons why people are interested in Elf & Stacy [Toby's music project], because it sounds a bit different. When we first got played on the radio, they selected us because they thought it was really refreshing. And that's probably to do with being here and not being caught up with what everyone else is doing.

If everything starts to look the same, if everyone starts to dress the same, does the same thing, there's no alternative. That's what I feel certain areas of London are becoming like. That's not why I left, that's just an observation.

Is there anything you miss about London? I love cinema, so that's one of the things I really miss. Just being able to go and see a cool film at the drop of a hat. Here there might not be anything on that you want to see, so it's less spontaneous.

Multiculturalism is another thing I miss. The noise, the smells, the colour, reggae blasting out of shops — I think that's really inspiring. There aren't many cities that are like that.

How do you feel about Hackney now? You lived there long before it got so popular. It's just London, isn't it? Twenty years ago Notting Hill used to be really fashionable and then prices went crazy. Then it was Shoreditch and then Hackney. It's how it works.

But sooner or later I can't think of anywhere else in London. Maybe it's places like this, Margate, Hastings, Ramsgate, the 'new places'

And there's no spotlight on this place. You can do whatever you want, and you don't feel like everybody's judging you. In London there can be a bit of a snobbish attitude sometimes.

How easy did you find it to connect with the community here? Walking down the street with you and Beth feels like you know everybody. We were lucky because we opened a shop [selling vintage furniture, children's clothing and world cinema DVDs] when we first moved down. We had it for 3 years. Everybody came into that shop and we made some really good friends. It is a small town, so it's easy to find people you've got things in common with. The cheap studio and house rents make this place really attractive for the creative community. There are a lot of artists and writers.

Do you think you can bring something new to this town coming from London? If you get out there, talk to people, make music, play live, then you're giving people something they might not have heard before. Something different. When I started doing the paste-ups around here, people really reacted to it. Even if it's just a tiny little bit, you can definitely influence something. If your music is being played on the radio and they mention it is from St Leonards, people might visit or take an interest. It might inspire locals to do something similar.

What are your ambitions for the future? I really want to be working towards tying everything up into one package – music, graphics and film – something where it all comes together. I also quite like the idea of working with other people again to create something new. At the moment I'm quite isolated, so I'm all for working with other people.

→ ELFANDSTACY.BANDCAMP.COM
→ FLICKR.COM/PHOTOS/TOBYUK

will be these forgotten little seaside towns. They are definitely having a renaissance now.

Also technology enables you to be anywhere you like. You can make a picture here and send it to a client in New York. If you can get the work, it doesn't matter where you produce it. It's just getting the work that's the hard thing.

Do you think living here has changed you as a person? I've definitely become calmer. I don't get road rage anymore [laughs]. In London I always lived in rough areas when I was growing up. It's definitely more relaxed here, and I don't feel threatened in any way.

How do you spend your free time? My downtime is just about making music now. In London your whole week could be planned out, every night you could have something to do. Living here gives you space to think whereas in cities you don't really have that so much because there's always distractions.

TOP A completed jigsaw hangs proudly in the studio.

RIGHT St Leonards offers something Toby and his family couldn't find in London: the sea. 'Having kids changes your life... and being able to bring up Nancy by the sea has been amazing.'

BARNY CARTER & USCHA VAN BANNING founders of Uscha

'I still enjoy design, but it is not only about that anymore. Even though it's my passion and it still excites me, my priorities have shifted'

Amsterdam → Melbourne → **Byron Bay, New South Wales, Australia** population 5,500

After separate careers in interior design and film direction, USCHA *and* BARNY *opened a homeware shop in Melbourne, selling hand-made products with a focus on sustainability and simplicity. On a path to greater self-sufficiency and freedom, moving away from the city seemed like the natural next step. Attracted by the beach and the creative community, they settled in Byron Bay, where they have opened another shop. Surrounded by stunning natural landscape, and plenty of wild animals, they have found the ideal place to raise their son and explore alternative ways of living and working.*

What made you want to leave the city? USCHA VAN BANNING: It was meant to be. From the moment I moved to Australia, Barny always wanted us to live here.

I'm a real city girl. I never thought I would move to the countryside. But then I never thought that I would move to Australia either [laughs].

BARNY CARTER: I grew up in Melbourne, but I have always been a nature person at heart, so it was a natural move. In Byron

Bay we are surrounded by untouched nature. The lifestyle is completely different. It's more about living than working.

I feel in a city you are just stuck in traffic and deadlines until the end of the day. Then you sit down and have some wine, and that's how you relax. It's not bad, it's just a different lifestyle. There are millions of people doing the same thing, and you're just part of that cog. Even though we had our own business it was very hard to get out of that. Here it is a lot easier to go at your own pace. There are more options even though it's smaller.

UVB: We wanted to feel more connected. You are so detached in the city and feel very reliant on the system. Here we go to the supermarket, yes, but we buy most produce from local farmers and small family shops.

Of course, you still have to make money and pay your taxes. You can't run away from all those things, but the balance is totally different. We can hear the ocean from our house. If you look out from our back garden, you see palm trees and lush vegetation. It is just bush. You're woken up by koalas – which are horny bears [laughs].

BC: In Melbourne I would struggle to get out of bed, now I go for a surf at 6 o'clock. It's great to do something physical and get this influx of nature in the morning. That boosts me for the whole day. It's priceless.

Why Byron Bay? BC: I think it's one of the most beautiful locations in Australia. The climate is amazing, we've got pristine beaches, and you see dolphins and whales. There is beautiful greenery, lush tropical forests, and sharp mountains that are covered in mist at the end of the day.
UVB: It's really kitsch [laughs].
BC: It is also known for being a very

creative town, and is home to businesses that are more ethically minded. People who come here don't want to be stuck in the mainstream; they are all doing their own thing.
UVB: For Australia it's really multi-cultural. It definitely attracts people that care about the environment and want to live a more sustainable life.

Uscha, you said you wanted to get out of the system. Can you describe what that means to you? UVB: In a city it is really hard to escape this career thinking. It feels a bit robotic, like the 'Truman Show', almost. You bump into a friend and ask them how they are, and they go, 'busy'. That's what people say to each other. With what, exactly? You can always come up with a list of things that you have to do. I'm a master in it. At the end of the day it doesn't really matter.

I mean, we're not camping in the bush totally off grid, but there is less pressure to make a lot of money. You realise you don't need that much. It's liberating. It gives you a lot of extra time to enjoy life. It opens your eyes and allows

PREVIOUS SPREAD Uscha and Barny have noticed a huge contrast in attitudes to daycare, and family life, since moving out of the city.

LEFT Barny and Louis [Barny & Uscha's son] enjoying a drumming session.

TOP Buying produce from the local farmers' market and small family shops feels more rewarding, says Uscha, than shopping at big supermarkets: 'You feel so detached in the city.'

you to appreciate things that you would have missed before.

Do you feel a greater sense of freedom here? UVB: Yes, on various levels. In Amsterdam I always felt my clothes very quickly looked old or I couldn't walk out the door without mascara. People like to judge each other. You have less of that in Australia, but when you move away from the city that totally drops away.

Most of the time we haven't even showered [laughs]. You just wear the same things. Friends like you for what you are, unlike in the city where you have all these layers that make up your identity.

On the other hand we still have our business. That can be challenging because it's all about image now. You have to sell a story.

How has the move affected your business? UVB: Having enough work is definitely a big challenge when you move away from the city. It is quite competitive. I think some people feel a bit threatened by us here. You have to reassure them that you're not going to steal their customers.

In the city you don't really have that. Even on our street in Melbourne we saw a lot of shops opening that were similar to ours. We thought it was positive. It attracts more people and you feel we can all share the cake.

You have to work a little bit harder to get to people's hearts. Once you're in you're in, that sort of thing. But we definitely feel that we have to prove ourselves a bit more in this small community.

Can you tell me about your new shop? BC: We recently opened a space as part of a collective. We want to be part of the creative community. Now we are part of a pop-up in a new commercial/residential precinct called the Habitat, with a mix of local homeware businesses. It's a new exciting development with a strong environmental focus.

LEFT In addition to their Melbourne store, Uscha and Barny were invited to be part of a new pop-up space in Byron Bay called 'Habitat'. Under their brand name Uscha, they sell handmade products with a strong focus on sustainable living.

What's the plan for the Melbourne shop? BC: We'll keep it running for the foreseeable future. We have a new manager that we're very excited about and we also have our old home upstairs that we renovated with our own hands. It allows others to experience our philosophy on living through Airbnb. Everything has purpose and is handmade with natural materials.

We think there's a great opportunity to create a space in Byron Bay as well. When people experience our space they truly understand the benefits of simple living.

What's your living situation here? UVB: We're renting at the moment, but our dream is to build something ourselves. I'm a cabinetmaker and in Holland I used to do interior architecture. Barny worked in the film industry for 10 years as an art director, and he's quite handy as well.

We want to build a little structure where we can live, something small. We don't need a big house. Around here you spend most of your time outside anyway. You're always fighting animals like termites in your house, so you'd rather have it small. It's less of a hassle.

Has your relationship to nature changed? UVB: It's funny... I'm allergic to wasps and bees. Every summer in Holland I had to worry about not getting stung and carry an EpiPen [used to administer medication to someone experiencing anaphylaxis] with me. Now we live in Australia and everything is poisonous. In Melbourne you have the odd spider here and there, but we are in serious bush. There are lot of really poisonous snakes, spiders and even poisonous snails. But I don't carry my EpiPen around anymore. Here, I could die from anything, like everybody else. We're all in the same boat. It's just what it is.

Being closer to nature makes you less afraid of it. In the city you're a stranger to all of this and every little piece of nature is scary.

Do you feel moving here has had an impact on your health? UVB: I do feel healthier. Just the air you breathe makes a big difference. I notice whenever I am in the city now, and it makes me feel a bit toxic. I am surprised that it happened so quickly.

USCHA VAN BANNING **'Being closer to nature makes you less afraid of it. In the city you're a stranger to all of this and every little piece of nature is scary'**

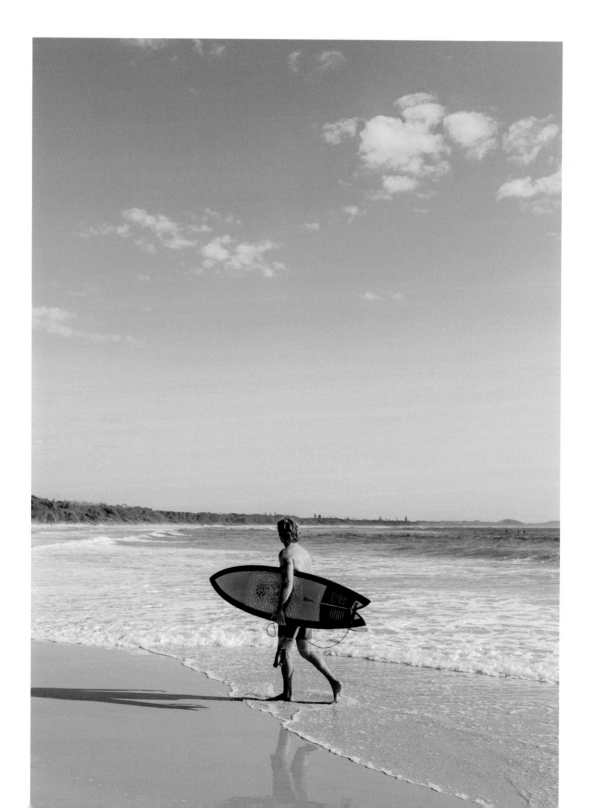

I feel a lot calmer mentally, too. My life used to be about design, and I was constantly feeding myself with images, stimulating my senses with content. It was also a way of numbing other feelings in me.

I still enjoy design, but it is not only about that anymore. Even though it's my passion and it still excites me, my priorities have shifted. Now I also enjoy doing nothing and just 'being'.

It's funny because I used to feel suffocated after spending a few days in the countryside, thinking, 'take me out of here, there's nothing here'. Now it's the opposite.

Do you find it easier to combine parenthood and work in Byron Bay? BC: The approach to daycare is so different here. In Melbourne daycare runs until 6 or 7 o'clock and you're happy if you find a place where you can leave them as long as possible. Here they close at 5 o'clock and everybody's gone by then. People pick up their kids and go to the beach to be together as a family. The whole town is out and about. You realise that this is actually much more important.

What is your approach to social media or spending time online? UVB: In a way the Internet makes it easier to move out of the city. You don't feel like you're missing out. I can still see everything that happens in the world or look at things that inspire me; I don't have to be in the city for that. But it can also numb you. If you get too much information it makes it hard to think creatively yourself.

Do you feel you can bring something new to Byron Bay? UVB: To be honest I feel like I still have a lot to learn. Even with growing vegetables in our garden – these basic things are not easy. You think you can harvest your broccoli and a day later it's all gone, because an animal has eaten it. Often I feel like a city girl that still needs to learn a lot, getting a heart attack mistaking a stick for a snake.

Living in the countryside and growing your own food is a romantic idea, but it can be really hard work. UVB: Definitely. We are growing beans, and I think we have three that didn't get eaten. You appreciate food a lot more, just having our little veggie garden here, that's for sure.

Still, it feels good. Everything is so convenient in the city, but it's a very fragile system. It's quite scary to think what would happen if it fails. You start to realise, 'shit, I don't know anything. What happens if I can't buy my food in the shop?'

The week we moved here there was a typhoon. It was very windy and raining heavily for days. We didn't have electricity and everything got flooded around Byron Bay. It's pitch black, there's nothing. It's a really unsettling feeling. You go, 'oh no, I only have 2% battery left on my phone. What are we going to do?' [laughs].

I think more and more people are aspiring to live in a way that gives them a greater connection to nature. UVB: You definitely see it more – with the tiny houses movement for example. People are searching for more freedom. You're almost forced to if you don't have family that can financially support you. If you want to have a certain lifestyle you can either buy in the city and work your ass off for the rest of your life, or you can move to a depressing suburb. Two bad options. Why not opt for the total opposite and go on a new adventure?

What would be your advice for somebody wanting to move out of the city? UVB: Just do it. Often people overthink things. It doesn't matter how much you prepare yourself, you are never going to be prepared. It's like having a child. It's absolutely not easy, but there's not a second that we feel that we want to go back. It only makes us stronger.

→ USCHA.COM.AU

PREVIOUS SPREAD BOTTOM LEFT A python sleeping on the rocks at the beach. Living in an environment with wild, and potentially dangerous, animals forces them to keep their eyes open.

PREVIOUS SPREAD RIGHT Barny admits to struggling to get out of bed in Melbourne, but now surfs at 6 o'clock every morning.

RIGHT From its pristine coastline with dolphins and whales to the lush tropical forests and sharp mountains, Byron Bay seemingly has it all. Or as Uscha puts it: 'It's really kitsch'.

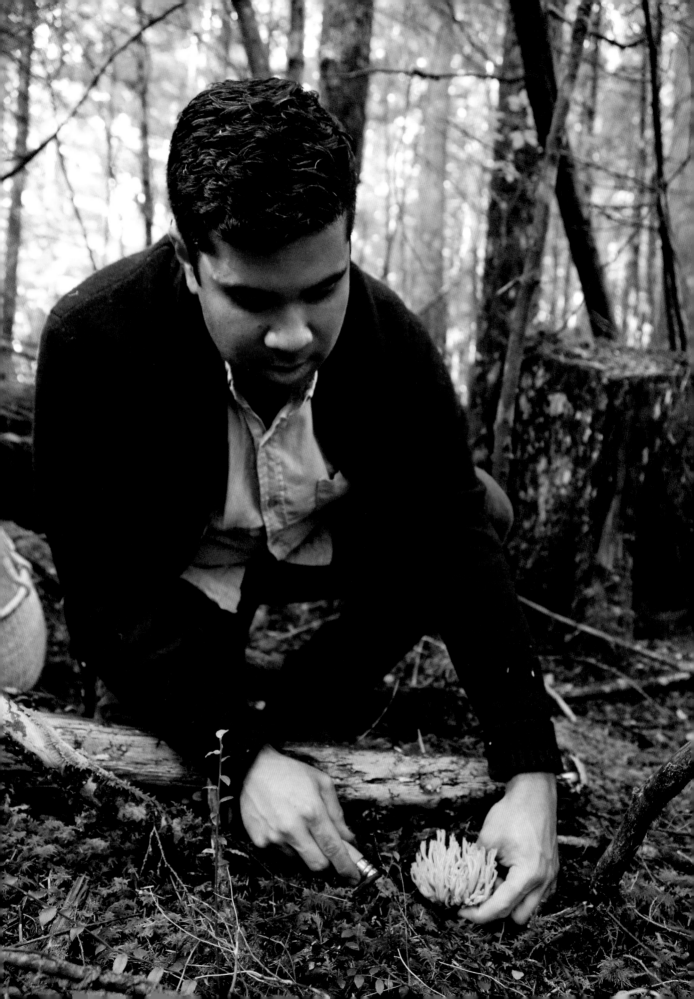

RYAN DOMINGO chef, co-founder of Larch Provisions

'What inspired us to move was the idea to simplify our lifestyle, trading the convenience for a richer life'

New York → Portland → **Corbett, Oregon, United States**
population 3,400

RYAN *was working as a chef in New York City when he met Emily at a rooftop party he hosted. The pair hit it off quickly and, 6 months later, moved in together in Brooklyn. But before long, a yearning for more space, more trees, less traffic and a closer proximity to their favourite hiking and foraging locations took hold. Three years ago, after a stint in Portland, they eventually settled in the small town of Corbett, near Larch Mountain. Their new location provided inspiration for their catering company, Larch Provisions, which focuses on the abundance of wild produce that surrounds their home. Foraging for ingredients year-round, the pair prepare only the most local and seasonal dishes, and are striving to bring a different kind of cuisine to the rural population they're based in.*

What made you want to move to the countryside? We were living in Williamsburg and really loved the energy of the city, but we were missing a quality of life that we couldn't attain there. We decided to move back to Portland where Emily still owned a flat. We made the most of it, but we still felt trapped in a way.

We did a lot of camping one summer, really getting closer to nature. We stayed at an old fire lookout built on stilts in the middle of the national forest for 3 days and had this brain-storm session about our future. What inspired us to move was the idea to simplify our lifestyle, trading the convenience for a richer life.

Why Corbett? We had some friends who lived out here, and had visited a few times. The people we met were very creative and in the same spirit as us. Corbett is at the beginning of the Columbia River Gorge, which we think is the most beautiful place in Oregon. It's an old rural farm town in a very bucolic setting.

We thought we could extend our concept for a wild and seasonal cuisine if we were closer to nature, so we just did it. We bought this house on a whim. It wasn't expensive by today's standards, but it was really run down. We've spent the last 2 years renovating it, and it's been so satisfying to see the transformation.

TOP Ryan and his wife Emily spent 2 years renovating their new home in Corbett, an old farm town in rural Oregon.

RIGHT Chanterelle mushrooms found in the nearby forest, one of the many wild ingredients Ryan and Emily use in their business's highly seasonal cuisine.

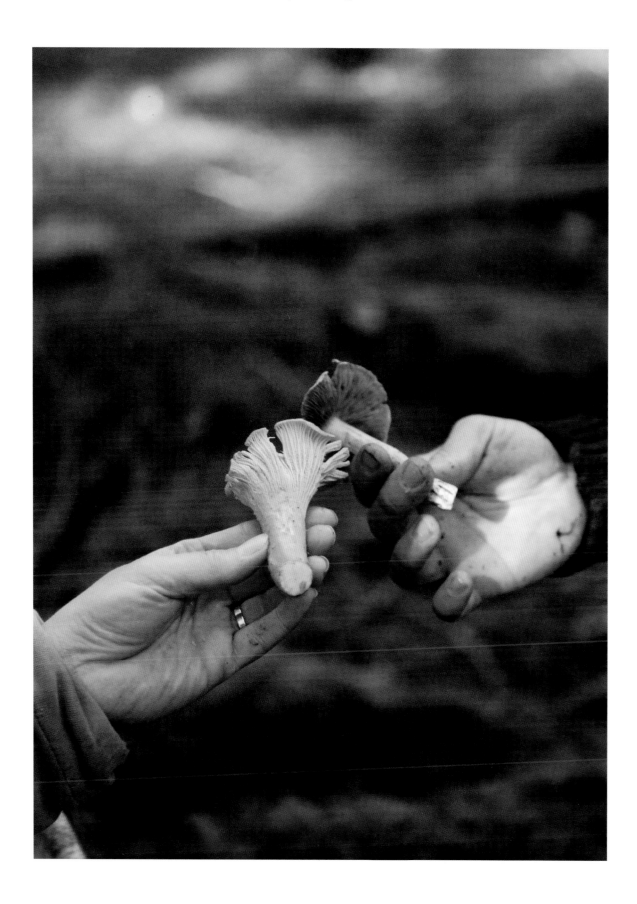

RYAN DOMINGO 'We thought we could extend
our concept for a wild and seasonal cuisine
if we were closer to nature, so we just did it'

What else have you been up to since you moved here? We started our catering business, which has been really exciting. We're at a point now where we don't work at other part-time jobs anymore, we just focus on our company. We're really happy about that.

We called it Larch Provisions because we live at the base of Larch Mountain and it was such an inspiration with all the wild ingredients that we forage there. It has become a part of our cuisine.

Did you have any knowledge about wild plants before you moved? We definitely had a base knowledge, but gradually got more interested. We got a bunch of books and keep studying every time we go out there.

When we were working in some of the better restaurants in New York and Portland we had the opportunity to see foraged foods being used in modern cuisine. But it was never on a large scale – it was always a very small part of the menu. We did a lot of research on the gathering of wild foods, specifically what is available in the Pacific Northwest, and got to a point where we can harvest all year and incorporate it in our menus. We source and preserve a lot of food from our local area.

We also focus on cooking styles that were native to the area, and the traditions and stories around that. For example, there's a dish called pemmican, which is an Alaskan dish of cured meat, animal fat and dried berries – it's the original protein bar. It will keep indefinitely if it's done the right way. We do a dish that's inspired by that, which is an elk tartare with dried berries and liver mousse. We take inspiration from these traditional dishes and then we try to modernise it.

Do you experiment a lot to come up with new recipes? We try to be as experimental as we can, but when you cook for 200 people you just want to put something on the table that's approachable and delicious.

The way we eat is not how most people in Corbett eat. You'd be surprised by how simple people's tastes still are. Most people don't even

eat vegetables and wouldn't know what some things are that you can find at the farmers market. We want to cook food that's just a little bit more interesting, a little bit healthier, and teach people about new ingredients. It's been challenging, but fun as well.

How do you make this kind of food approachable for people in the rural area? I like to take classic American dishes and

PREVIOUS SPREAD TOP RIGHT Frittatas with calendula flowers and borage — courtesy of Emily's mum, who supplies Ryan and Emily year-round with flowers and herbs.

PREVIOUS SPREAD BOTTOM RIGHT Ryan and Emily were drawn to Corbett as it offered them easy access to Portland, the open space that's synonymous with the region, and the bounty of natural ingredients in the Pacific Northwest.

LEFT The view across the Columbia River Gorge.

TOP Sometimes a gamble pays off. 'We bought this house on a whim', says Ryan. 'It was really run down... and it's been so satisfying to see the transformation.'

incorporate more vegetables. Or prepare vegetables in different ways, like smoking, pickling or charring.

We often use salad, something that everybody eats, as a way to introduce different things like acid, richness, texture, colour and umami. Something as simple as a salad can be a starting point for people to understand that there's so much more flavour to food.

What has been the biggest challenge for you? An interesting aspect of living in a rural place is dealing with extreme weather conditions. We're in forest fire country, and recently a fire burned 15,000 acres near our home and was threatening a lot of communities in Corbett. We had to evacuate.

The winters here are brutal. We get a ton of snow and the road gets covered in a thick sheet of ice. Every time we go outside we have our crampons on [laughs].

It's pretty regular that we lose power, sometimes for up to 5 days, so we had to find a way to be more self-reliant. We have a

generator and a lot of gasoline, which we can use to power the refrigerators, the freezers and the kitchen. When you have thousands and thousands of dollars worth of food – half of a cow, a freezer full of lamb – it's a different type of worry. It is our business and our wellbeing that we're putting at risk.

We just deal with it. Trading the convenience that we loved for working a little harder. The reward lies in being close to nature.

How did you connect with the local community? We made more friends and connections in 3 years living out in Corbett than we did in the last 10 years living in cities. That's been really nice. It seems the further away you get from these urban centres, the more people crave a connection with each other. And not just small talk, but how to help each other or create more of a community.

We share the driveway with two couples who are quite a bit older than us. They are always dropping stuff at our door – a dozen eggs or pickles. They're just really sweet.

We miss having a community gathering space such as a coffee house or restaurant though, and we want to come up with ways to improve that. Emily has joined the Mud Hens, which is a handful of women that gather weekly at a local potter's studio to make clay. She has also created a monthly book club where everyone brings a dish related to the book.

What's your approach to social media? We love the utility and the creativity of it, but we don't love being tied to our devices. We're constantly trying to do less on our computers and phones. If it was up to us, and we didn't have the business, we would use social media a lot less, but it really is beneficial to us. It certainly helps to give people an idea of what we do and to promote our events.

Where do you get your customers from? We get most of our business through word of mouth. We do events all over Oregon – in Corbett, Portland, and some in the wine country where there is a lot of beautiful farmland. We'd love to do more events there. You can't really tell the story of Oregon food without incorporating the amazing Willamette Valley wines.

We also do a lot of farm dinners, food for corporate meetings, breakfasts, birthday dinners, and we do 200-people weddings.

Do you have any employees? We don't, but it's tricky because when we do those large events we need up to a dozen people to help. We don't like the idea of hiring inexperienced people – that's what a lot of catering companies do – because service is so important to us. We have a long list of friends from working in restaurants that we can call upon; people who have the same standards that we do. We're still within reach of Portland, so we have the opportunity to get help. Being further away would be tough.

What are your plans for the future? We love the flexible lifestyle and making our own schedule. In January we're taking a month off to go travelling in Peru.

We want to continue to grow our catering company. We got really close to opening our own restaurant a few times, but for one reason or another it didn't happen.

Restaurants are going through a shift right now. The price of food is increasing, but people don't want to pay more. So many wonderful restaurants in Portland are closing, so we're not sure that's the answer.

One of our larger ambitions is to have a place where people can stay – a venue for weddings and bigger gatherings, and a place where we can spread this message about food. It might happen here, or in the wine country. We'll see.

→ LARCHPROVISIONS.COM

RIGHT The woods near Larch Mountain where the pair often forage for mushrooms.

NATALIE JONES founder of Caro

'In London I was always chasing. You constantly have this anxiety about not being good enough: not having a good enough job, not earning enough money, not wearing the right brands'

London → **Bruton, Somerset, United Kingdom** population 2,900

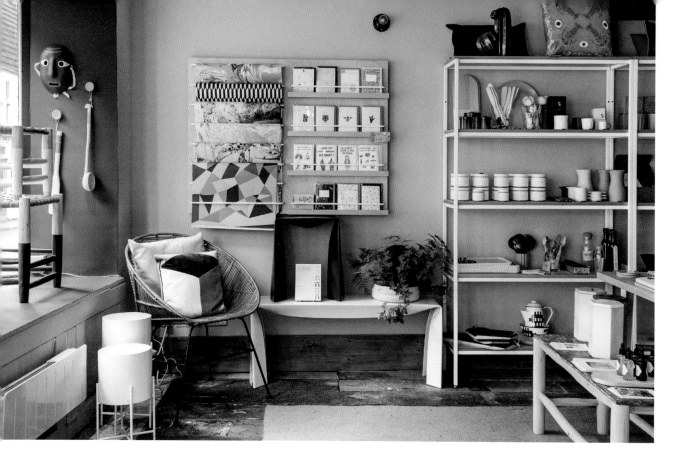

NATALIE *swapped the hustle and bustle of her London agency life for a rural existence in the picturesque town of Bruton. Also home to the prestigious Hauser & Wirth gallery and upmarket restaurant and hotel At The Chapel, the Somerset town has become a destination for a design-minded crowd, providing a fertile ground for Natalie to open her lifestyle boutique Caro. Although getting used to a certain village mentality wasn't easy for this Londoner, she enjoys being more in control of her life — combining work and motherhood more easily, and slowly building up her brand that now encompasses a shop, regular events, product collaborations and a bed and breakfast.*

What brought you to Bruton? My husband is from Somerset. He's a history teacher and has always lived here. We met at a bar in London 10 years ago, and for 6 years we travelled between here and London. After a while we both realised that we couldn't go on like this. He was very against moving to London, and the only thing I could imagine was doing my own thing, like opening a shop. The only place I considered was Bruton, because it is creative and attracts the kind of audience that interests me.

I noticed there were no shops tailored to people like me, and I thought that I couldn't be the only one around here who's of that sort of mentality.

We started looking for houses in 2014, while I was still working in London. This house came up and we went to view it. It was a complete tip. Tom is not very visually minded, but I could see potential. I am quite impulsive, so I put an offer in when he was away on a school trip. He couldn't get in my way [laughs]. The offer got accepted and what followed was probably the most stressful time in my life. Organising mortgages and planning everything was really tough. But I really wanted it. I couldn't have moved here without a goal and without work — I needed a focus. I had a good job in London. I was earning alright money. To just give up everything would

PREVIOUS SPREAD Natalie in front of her home in Bruton.

TOP Natalie's store Caro sells a curated selection of 'objects for life and home sourced from around the globe.'

RIGHT In a collaboration with a local chocolatier, Natalie created a chocolate bar inspired by the surrounding countryside.

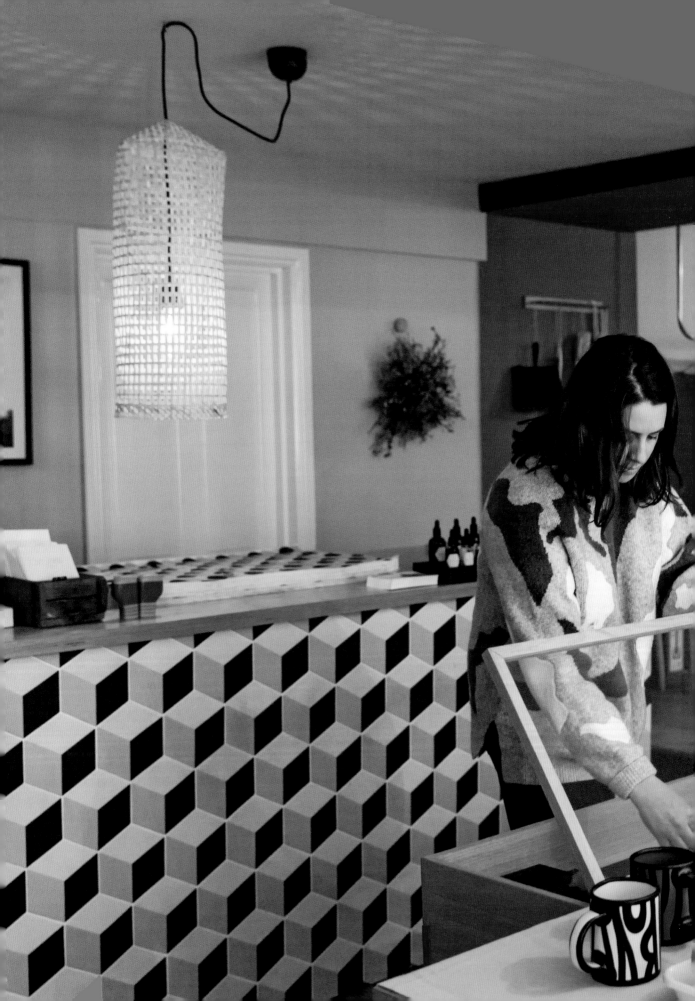

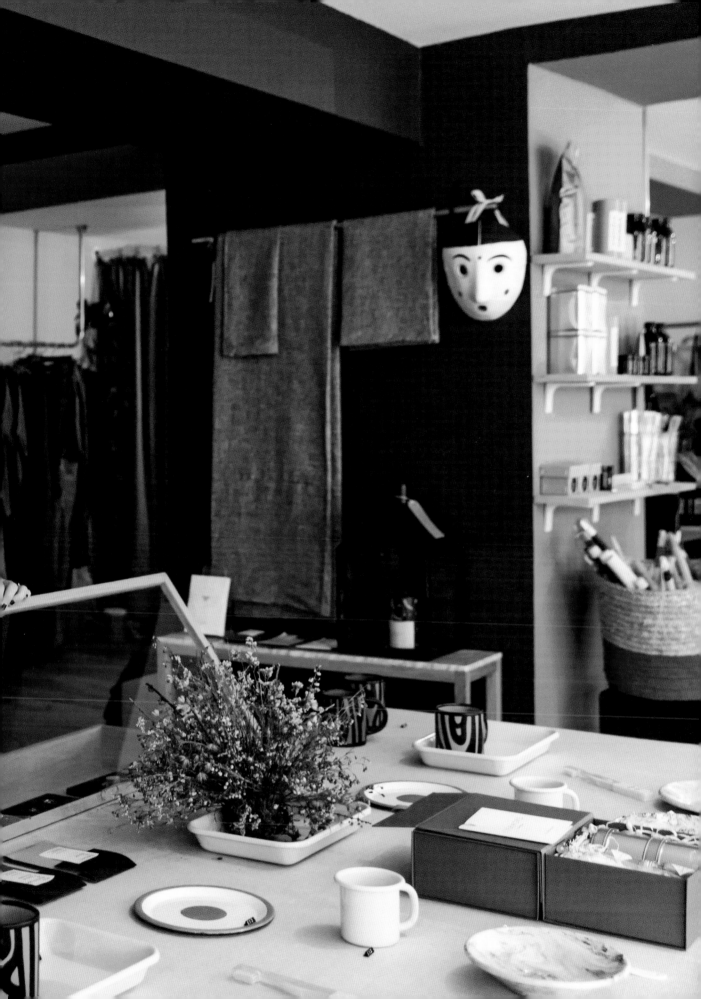

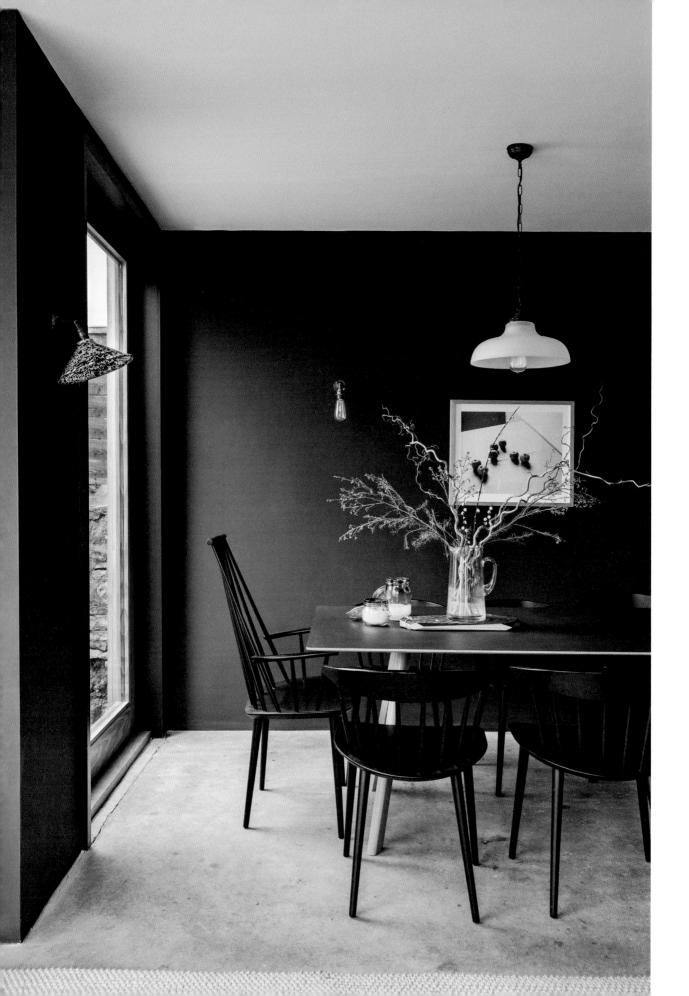

I felt much more in control of my life. In London I was always chasing. You constantly have this anxiety about not being good enough: not having a good enough job, not earning enough money, not wearing the right brands. Materialism exists here, but it's just not the same.

What is interesting is that people who are moving to the countryside now are getting much younger, some in their early 20s. I used to think that's what you do when you retire or have kids, but I've noticed that's not the case anymore. A lot of people are sick of urban life and they want a new existence.

How has it been so far? Very up and down. The mentality here can be frustrating sometimes. I was naive about village life. When I first opened, people would come in the shop and go, 'what is this place, a shop or a cafe?' They just could not understand. I mean it's not exactly retail on the edge [laughs]. But for some people everything needs to be in a box. That took a lot of getting used to. Also when you're in a shop you put yourself out there for people to talk about you. In London you don't go into a shop and want to know everything about the shopkeeper.

Things are different now. If you have a shop you also gain access to the community very quickly. I've made some incredible friends here who are lovely and welcoming, and there is so much creativity. There are writers, artists, filmmakers, stylists and photographers. We all have dinner at people's houses. At The Chapel, a local restaurant, has a cocktail hour and you just bump into people. You don't have to make arrangements. It's so nice to have that local community.

You recently moved to a new location with your shop. How has it been so far? Moving to the High Street has been an exciting shift with a whole new set of people discovering

have been difficult, so I just made it happen. It was pretty stressful, but also exciting. I was creating this new life. Most of my friends thought I was crazy [laughs].

What was appealing about the idea of living in a small town? I had been coming here every other weekend. I loved the fact that as soon as I left London I completely relaxed. All the stress that comes with living in a big city fell away once I got on the train. I did have chronic anxiety for a while. I saw someone get hit by a train and that sent me into shock. And literally as soon as I came here, all the palpitations and panic attacks just disappeared. It was amazing.

PREVIOUS SPREAD Through her shop, Natalie has gained access to the local community very quickly. 'It's a great way to make new friends.'

LEFT & TOP With her keen eye for design, every detail in Natalie's home is carefully considered.

NATALIE JONES **'Materialism exists here, but it's just not the same'**

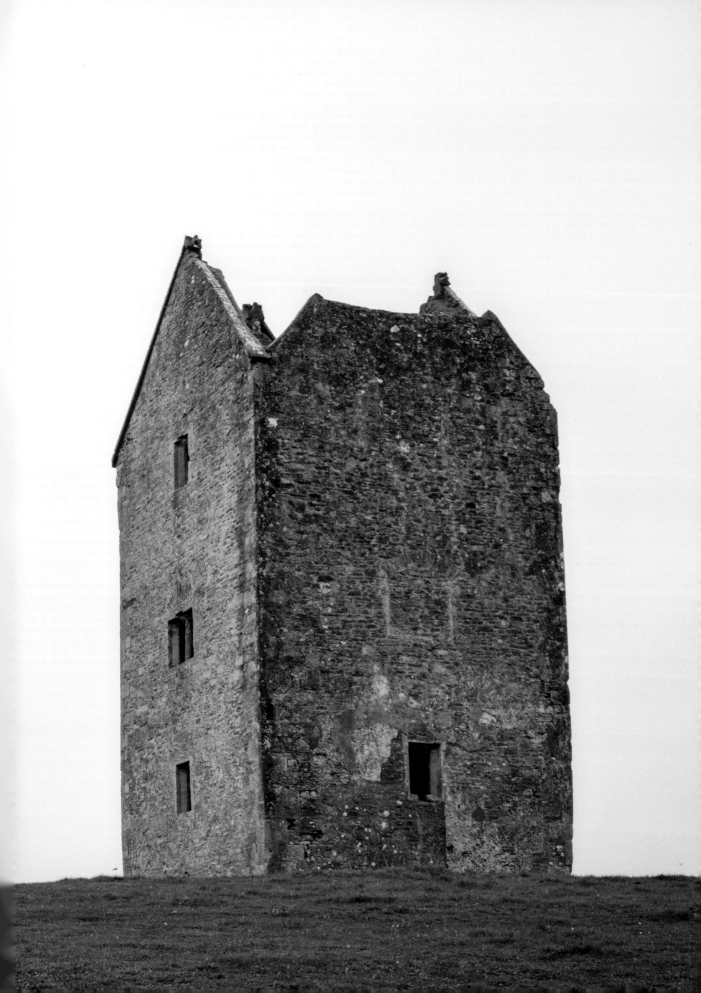

Caro as a brand. The square footage is much larger so I am able to buy more products and sell furniture as well. The space is also conducive to being more playful with different brands within the shop, and we have the space to sell womens-wear now.

Can you tell me about the collabora-tions you have been doing? Caro has launched a set of chocolate bars in collaboration with The Chocolate Society. Each flavour is inspired by the countryside. For example, the flavours of pine, black pepper and cracked almonds stem from childhood memories of the forest — my favourite place on earth.

Has living in the countryside changed your relationship to nature? Yes, I enjoy it more. I'm city born and bred, but having wit-nessed how it changes how I feel, I think I need it more. Being able to just get out and go for a walk in the woods is amazing.

How often do you go to London? About once every 3 weeks. I love going back. I think if I was just here and didn't access London I would feel quite isolated. I do need that conversation with London — there needs to be interaction.

Has your social life changed a lot? Conversation is different with people here. When I get together with my friends in London, we talk about work or stuff that we all have common ground in. The design world especially can be very cliquey; you only hang out with the same kind of people. Here there is a lot more curios-ity and exploring. In that sense it's very diverse. Everyone is very liberal and there is a lot of alternative thinking. Although it may not float my boat on occasion, it's still great to meet all these people. It opens your mind. You become more accepting.

It's also a great place to bring up kids. You don't feel afraid to have kids, because here everyone parties at the same time. You don't feel like your life is over.

Everyone's so different here, so there is less comparison. You find a relationship with so many different types of people which is refresh-ing, and it's fun. I'm way happier here.

How has having a baby affected your life? Having Arlo has given me perspective. Time is now so valuable which has resulted in a newfound respect for what I do outside the role I play as a mother. I have very limited time at the moment so I tend to organise meetings in the daytime and spend my evenings catching up on emails. Arlo comes everywhere with me — pho-toshoots, meetings and buying trips.

Are there things you miss about city life? There aren't a lot of cuisines here. You know, these sort of first world problems. I used to love spinning and boxing, but you can't do that here. I've been to ten different fitness centres try-ing to find somewhere good and you just can't. You're in a community hall with draped curtains and disco lights, and the kid teaching... I mean I could do a better job. It's just terrible [laughs].

Sounds like there is a gap in the mar-ket. A friend and I have been thinking about it. We've recently introduced yoga to Caro which is an exciting addition to our offering. The space overlooks an intimate courtyard and has a calming mix of white walls, a concrete floor, and large wooden framed windows, which lends itself well to the practice of yoga.

What are your plans for the future? We are thinking up our next product to launch with The Chocolate Society. Apart from that, I'm going to do a lot more events. It provides a nar-rative to what I'm doing and you can involve the wider community. At some point I'd love to open my own mini hotel somewhere.

→ CAROSOMERSET.COM

PREVIOUS SPREAD & RIGHT Even in typically British weather, Natalie appreciates how the simple act of going for a walk can positively affect how she feels.

CAIO **ANTUNES** co-founder of Made in Natural **& MARCELLA ZAMBARDINO** co-founder of Made in Natural & Positiva

'We are still learning to let go of all the comforts we are used to in the city, learning to depend on less material things'

Sao Paulo → Rome → **Serra de Bocaína, Paraty, Brazil** population unknown

CAIO *and* MARCELLA's *remote home is found deep inside a national park on the Brazilian coast. Making use of an abandoned piece of land that used to belong to Caio's grandfather, the young couple from Sao Paulo have been steadily building a self-sufficient existence that is in harmony with the natural environment that surrounds them. While their current set-up lacks Internet and a phone connection, they are still required to spend some time in the city, tending to the brands they have each created. But full of ideas and energy for new projects, they hope to make their house in the jungle a permanent base very soon.*

How did you discover this place?
CAIO ANTUNES: My grandfather bought this land in 1960. He built a small trout farm in the river that runs by the house, and he also planted fruit trees. My mother and uncle came to visit frequently when they were young, then, after my grandfather died when I was 3 years old, my mum kept coming here with me. Getting here from the city was like coming to another planet. I loved it.

When I was 19 I started coming to this area again to surf. I discovered many beautiful beaches and spots along the coast. I would spend a few days here and then go back to Sao Paulo. It was a base to sleep while I surfed and explored the area. To me this is one of the most beautiful and best-preserved parts of the Brazilian coast.

When did you move here? CA: I met Marcella about 6 years ago. She loved the idea of coming here more frequently, and staying for longer periods. After a while we decided that we wanted to live here, so we began renovating the house. We had to make it more habitable. We still don't live here all the time, but we hope to make that happen as soon as possible.

What changes did you have to make in order to live here? CA: First, we had to clean everything out. We enlarged the rooms and built

two new bathrooms. We brought some furniture with us, which was rather challenging – crossing the river with anything big is a complicated process – so we had a big group of people helping us. Some friends came to work on the land for us, helping us plant an agroforestry system. The place has changed quite dramatically over the last couple of years.

MARCELLA ZAMBARDINO: Initially, it looked like an abandoned home. Once we started work, the environment became much more alive as well. We have several fruit trees that haven't carried any fruit since Caio's grandfather lived here about 30 years ago, but now they are producing again.

Did you have any previous experience with plants or agroforestry? MZ: We learned by necessity. We had little knowledge about plants while living in the city. I did internships at organic farms and studied agroforestry. It was important to us to not only improve the house, but to take care of the environment in a coherent way.

We are based inside a national park, so are striving for a balance between human impact and environmental preservation. Nature is an organism that lives in communion with all its elements, all the time. The way we design planting beds should be good for the forest, and for us.

LEFT Marcella and Caio's approach to land management is one of balance: 'The way we design planting beds should be good for the forest, and for us.'

TOP Family history: a photo of Caio's grandfather at the trout farm he built on the nearby river.

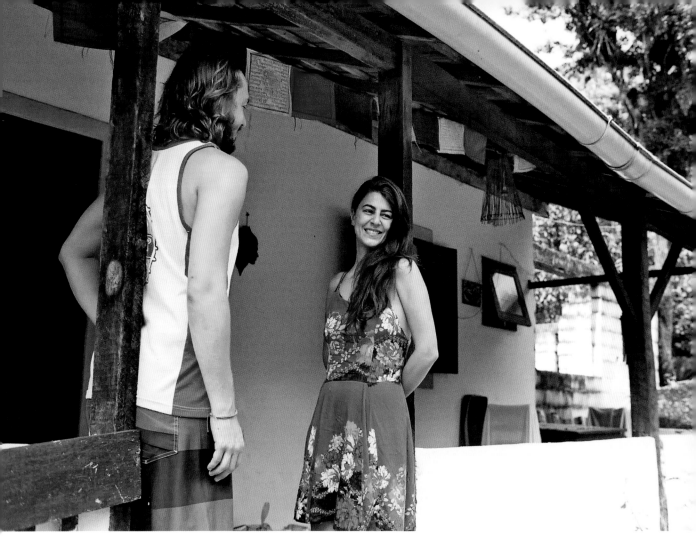

What was your main motivation to move? CA: To live a simpler life. We love being closer to nature and being able to do what we enjoy, at our own pace. Connecting with the natural cycles enables you to live in a more symbiotic relationship with your environment.

We are lucky to have both the mountains and the sea nearby. We also want to have children. Marcella and I both had a very urban upbringing, and we believe raising a child in this environment would be amazing.

MZ: What motivates us is the improved quality of life. Here things are simpler but better. We are still learning to let go of all the comforts we are used to in the city, learning to depend on less material things. But we often find it makes for a richer and more rewarding experience. Our environment provides us with everything we need. You just need to think a bit harder about how to make something, how to build it, what materials to use.

We don't have a refrigerator here which helps us to feed ourselves in a much more nourishing way – we plan our meals more carefully, and almost everything is fresh, picked just before we eat it. No fast food whatsoever.

How self-sufficient is your home? MZ: We are in the process of acquiring clean energy. This is a key requirement if we want this to become our permanent home. We do not intend to live with candles only [laughs].

Currently we are focusing on producing electricity with a water wheel system that Caio's grandfather installed and we are now improving. At the moment it doesn't cover all our needs, but we are looking to find some specialists to help

TOP Marcella and Caio on the porch of their house, once belonging to Caio's grandfather, nestled deep inside a national park.

RIGHT Fish exchanged for a painting with the local fisherman.

NEXT SPREAD Marcella using leaves for pattern making and printing.

MARCELLA ZAMBARDINO 'We learned by necessity. We had little knowledge about plants while living in the city'

us. We also have no Internet here at the moment. Once we have that it will be easier to work from here, further reducing our need to be in the city.

Can you tell me about your brand Positiva? MZ: Being here, I began to observe and understand the water cycle, forcing me to think more about biodegradability. Our system is cyclical, so I know I'm going to drink the water that I'm contaminating, requiring much more care with the kind of waste you put into it.

This led me to create my brand of biodegradable cleaning products. It's called Positiva and its differentiator is not only the biodegradability, but also the idea that we need far fewer products. One product can be used to clean the whole house, and lasts way longer than conventional cleaning products.

Caio, you also have your own brand. How did that come to life? CA: I was working as a freelance video editor, and I used the money I earned to travel and surf. I went to Asia, South America, and Oceania. When I settled back in Brazil again, and started renovating the house, I became more interested in food. One thing led to another and my brand of natural snacks was born.

As a result I wanted to understand more about how things were produced. I thought that ideally I would plant and produce the ingredients as well. The place here turned out to be a

fantastic testing lab to deepen my knowledge and experiment with different crops. Once I got more involved in the growing of plants myself, it was a path of no return. I discovered new fruit varieties, and learned about the forces that influence the cycles of nature.

What else have you been up to? MZ: I also started to make natural soap and developed a deep yoga practice.

All the courses and hobbies I do are tools to help me pursue my path to greater self-sufficiency. I studied fashion design and have worked in the fashion industry for a long time. I still design clothes for a handful of clients, but with the idea to produce 'slow fashion' – clothes that are made of organic cotton and designed to be really comfortable. I also make my own clothes, it's been a long time since I bought any.

Next I would like to learn to work with wood and bamboo, to build simple structures with the materials that are abundant here.

CA: I want to learn more about energy. Being here stimulates you and tells you what you need to learn.

How easy did you find it to connect to the local community? MZ: In Brazil, the farther from the city you go, the more hospitable people are. Our neighbours were very attentive, warm and caring. One of them used to work with Caio's grandfather, so he has a special connection to us.

We also love to hang out in Cunha, a small town nearby. It is full of like-minded people, working in everything from ceramics to alternative therapies. They have a similar outlook on life to ours, and we have a very enriching exchange of knowledge. And seeds [laughs].

TOP LEFT Coffee is an important ritual in Brazil, and is typically brewed using a cloth colander.

BOTTOM LEFT The bridge that connects the road to the house. Crossing the river with anything big can be quite a challenging process, but one that locals were all too happy to help with when the young couple moved their possessions.

TOP Caio showing a photo of the clouds on his phone – a tool he is less and less reliant on since moving to the middle of the rain forest.

What have been your biggest challenges? CA: We have neither Internet connection nor phone reception here, so we are quite isolated. In the city you have access to everything all the time. Being here requires you to plan more in advance, thinking about what resources we might need. Here there are always things to do. Work never ends.

MZ: We learned quickly that no one is going to come here and solve our problems. When something breaks we need to be able to solve it alone. We can only know how to evaluate or ask for help if we know how to do it ourselves.

For me it was also challenging explaining my life plan to my family, as it is very

different to theirs. I want to live with less material things and be more in touch with nature. They think I'm a crazy hippie [laughs]. However, they support us. My dad told me recently that I never liked staying in one place for too long. I've always been on the road and travelling for a long time. He believes I have finally found a place to settle.

Another challenge is not knowing if something bad has happened to someone dear. That's why we want to have Internet here soon. Still, the increased quality of life is infinite. We feel our bodies are thanking us for being here. I feel I am doing the right thing.

In which ways is your life different to your life in the city? MZ: The perception of time is different. In the city time flies and we dedicate ourselves to activities that are not always healthy or essential to life.

Having lived in the city before, do you feel you can bring something new to the rural environment? MZ: I believe in the power of exchange. An outside look always sees more beauty in the local culture or everyday life. The city has provided us with a lot of knowledge and tools that we take with us. Wherever we go, we want to have a positive impact.

What are your plans for the future? MZ: We want to produce enough energy to fulfill our needs, and to have some free animals to help produce our own food. I also want to give yoga classes, be a mother, and many more things. I love to create and I cannot stand still.

CA: She really can't [laughs].

→ MADEINNATURAL.COM.BR
→ POSITIVA.ECO.BR

TOP The simple life can be tough, Marcella admits, but the benefits are many: 'We feel our bodies are thanking us for being here.'

RIGHT Never content with staying still, Marcella says she next wants to learn to work with wood and bamboo, 'to build simple structures with the materials that are abundant here.'

NADIA RIVELLES
Photos by Mario Kiener (P. 6, 8-10, 12-16)
and Karen Rosenkranz (P. 7, 11)

BRIAN GABERMAN
Photos by Brian Gaberman (P. 20-25)
and Noelle Gaberman (P. 18, 27)

AMITA KULKARNI
Photos by Fabien Charuau (P. 28-38)
and Amita Kulkarni (P. 39)

MICHAEL WICKERT
Photos by Claudia Bühler (P. 41-51)

BRIAN BOSWORTH & JAMIE POOLE
Photos by Karen Rosenkranz (P. 52-60)
and Jamie Poole (P. 61)

BARBARA AMBROSZ
Photos by Thomas Raggam (P. 62-73)

CARLA PEREZ-GALLARDO
& HANNAH BLACK
Photos by Heidi's Bridge (P. 74-84)

LYNN MYLOU
Photos by Amie Galbraith (P. 86-97)

LUKE EVANS
Photos by Claudia Rocha (P. 98-109)

IVANO ATZORI & KYRE CHENVEN
Photos by Ivano Atzori (P. 111-123)

PAUL WEBB
Photos by Claudia Rocha (P. 124-127, 129-133)
and Abbie Trayler-Smith (P. 128)

MARIANA DE DELÁS
Photos by Mariana de Delás & Gartnerfuglen
(P. 134-135, 138-139, 141 top) and Karen
Rosenkranz (P. 136-137, 141 bottom, 142-145)

RAINER ROSEGGER
Photos by Karen Rosenkranz (P. 146-150,
152-153) and Andreas Trump (P. 151)

ERIC VIVIAN & YOSHIKO SHIMONO
Photos by Yu— (P. 155-163) and Yoshiko
Shimono (P. 165)

RICCARDO MONTE
Photos by Cloé Ando (P. 166, 173 top,
175 top), Davide Tartari (P. 167, 168 top),
Katie May (P. 168 bottom, 174, 176),
Mario Curti (P. 170-171), Riccardo Monte
(P. 173 bottom, 177) and Giordano
Saccardo (P. 176 bottom)

BAI GUAN & HUANG LU
Photos by Huang Lu (P. 178-189)

RACHEL BUDDE
Photos by Roseann Bath (P. 191-201)

TOBY WARREN
Photos by Karen Rosenkranz (P. 202-209)

BARNY CARTER & USCHA VAN BANNING
Photos by Anwyn Howarth (P. 210-214,
217-219) and Uscha van Banning (P. 216)

RYAN DOMINGO
Photos by Josh Wasserman (P. 220,
222-223, 225 bottom, 226) and Karen
Rosenkranz (P. 221, 224, 225 top, 227-229)

NATALIE JONES
Photos by Claudia Rocha (P. 230-241)

CAIO ANTUNES &
MARCELLA ZAMBARDINO
Photos by Luiza Lacava (P. 242-253)

CITY QUITTERS
Creative Pioneers Pursuing Post-Urban Life

PUBLISHER
Frame

AUTHOR
Karen Rosenkranz

EDITOR
George Tyson

PRODUCTION
Sarah De Boer

GRAPHIC DESIGN
Barbara Iwanicka

GRAPHIC DESIGN INTERN
Shadi Ekman

PREPRESS
Edward De Nijs

COVER PHOTOGRAPHY
Front: Mariana de Delás & Gartnerfuglen
Inside: Yu—
Flap: Claudia Rocha
Back: Noelle Gaberman, Luiza Lacava &
Ivano Atzori

PRINTING
IPP Printers

ACKNOWLEDGEMENTS OF THE AUTHOR
I would like to thank the brilliant creatives and
entrepreneurs featured in this book, and the
photographers who captured their inspiring
stories. I would also like to thank Lobke Hulzink,
Amie Norman, George Tyson, Luiza Lacava,
Sonia Skins, and Josh Wasserman for the time
and energy they kindly contributed. Thanks also
to Fadela Hilali for getting me started, Sarah de
Boer for trust and vision, and Michael Tropper
for absolutely everything. This book is dedicated
to my parents, Elke and Gert Rosenkranz.

Trade Distribution USA and Canada
Consortium Book Sales & Distribution, LLC.
34 Thirteenth Avenue NE, Suite 101
Minneapolis, MN 55413-1007
T +1 612 746 2600
T +1 800 283 3572 (orders)
F +1 612 746 2606

Trade Distribution Benelux
Frame Publishers
Luchtvaartstraat 4
1059 CA Amsterdam
the Netherlands
distribution@frameweb.com
frameweb.com

Trade Distribution Rest of World
Thames & Hudson Ltd
181A High Holborn
London WC1V 7QX
United Kingdom
T +44 20 7845 5000
F +44 20 7845 5050

ISBN: 978-94-92311-31-3

© 2018 Frame Publishers, Amsterdam, 2018

Whilst every effort has been made to ensure
accuracy, Frame Publishers does not under any
circumstances accept responsibility for errors or
omissions. Any mistakes or inaccuracies will be
corrected in case of subsequent editions upon
notification to the publisher.

The Koninklijke Bibliotheek lists this publication
in the Nederlandse Bibliografie: detailed
bibliographic information is available on the
internet at http://picarta.pica.nl

Printed on acid-free paper produced from
chlorine-free pulp. TCF ∞
Printed in Poland

987654321